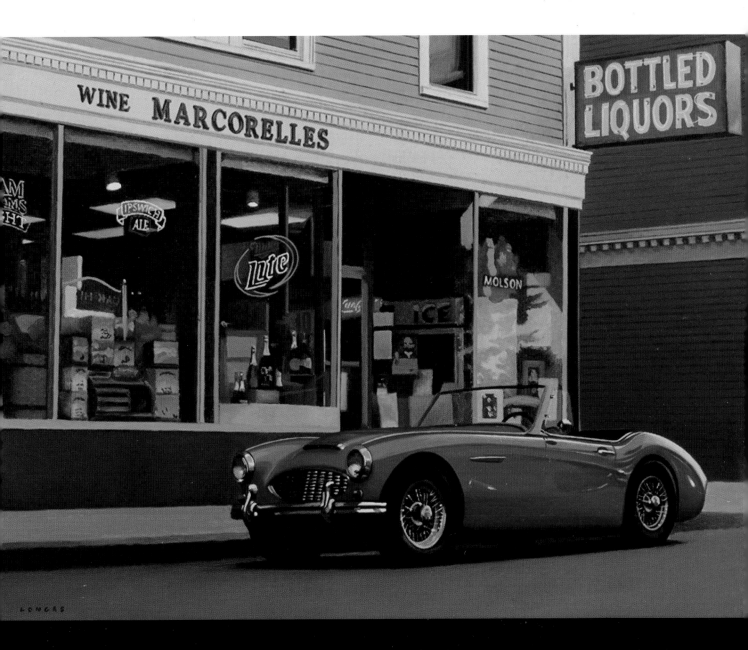

REALISTIC
PAINTING

STERLING
New York

HOW TO ACCESS THE ADDITIONAL CONTENT

You may access it by registering on the website or through augmented reality:

Through the web page:

Register at the website by signing up for free at **www.books2ar.com/pre;** scratch below and enter the code:

PREJ8CV3ND2C

Three simple steps:

1 Scratch off the rectangle

2 Access the website; enter the code

3 Sign up

What you'll find in the additional content:

Step-by-step exercises so you can see the process in greater detail.

Augmented Reality

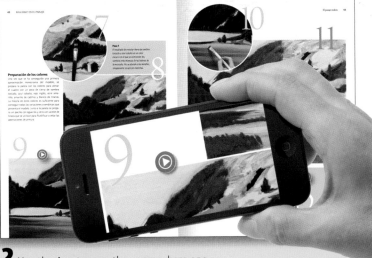

With augmented reality:

1 Download the AR application for IOS for free at:
http://www.books2ar.com/preios
or for Android at:
http://www.books2ar.com/preandroid
Or with:

QR for IOS QR for Android

 App Store Google play

2 Use the App to scan the pages where one of these two icons appear:

 This icon indicates additional **gallery work content.**

 This icon indicates additional **vídeo tutorials.**

3 Discover the content.

Three simple steps:

The App requires Internet connection in order to access the additional content.

 Download the App for free

 Scan the image where the icon appears

 Discover the content

 View gallery work for inspiration and ideas.

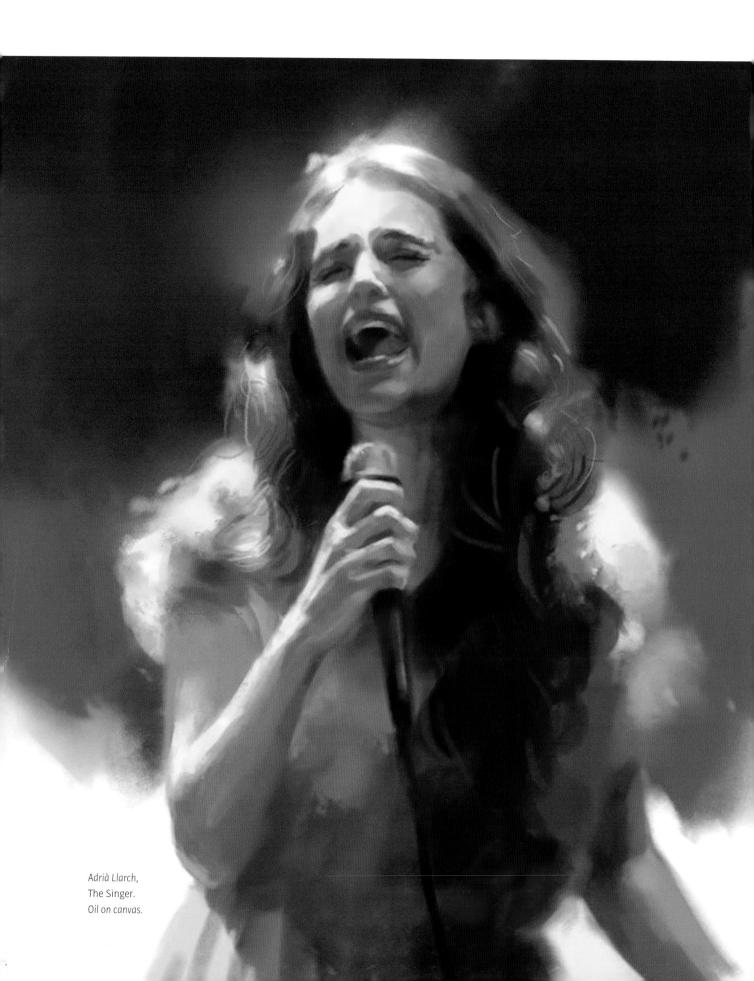

Adrià Llarch,
The Singer.
Oil on canvas.

CONTENTS

FROM HISTORICAL TO CURRENT REALISM

| 1

In learning about realistic painting, one must first look back to the Realism movement that appeared in France during the middle of the nineteenth century. Identified with the conceptual principles championed by French novelist Honoré de Balzac and his followers, Realist artists such as Gustave Courbet, Jean-François Millet, and Honoré Daumier were interested in capturing in their paintings the realities of the social issues prevalent at the time.

Instead of dreaming of lost worlds, medieval fables, and Eastern tales, as did the authors and artists of Romanticism, they aimed to represent everyday occurrences in the lives of people going about their business, performing their everyday tasks. This interest in portraying familiar objects and the faithfull reproduction of reality led many artists to paint outside in the open air (en plein air) and in front of live models, making studies and color notes directly on their canvases and then executing finished works in the solitude and seclusion of their studios.

Realism did not experience a decline with the arrival of Impressionism. But when the artistic avant-garde began to flourish at the turn of the century with movements such as Expressionism, Cubism, and Dada, Realism became marginalized. This departure from realistic representation became even more pronounced after wading through the tragedy of two world wars and the Great Depression. During this period, many artists adopted an existentialism and non-objectivity typical of abstract painting.

2

Today, and for the past several decades, there has been a new wave of artists who strongly advocate for the return of Realism in direct opposition to postmodern conceptual tendencies and the lyricism of abstract painting.

Contemporary realists promote a return to the painter's craft, to take up once again the techniques of the old masters, and in particular, those of classic nineteenth-century artists whose works reached an apex before the first wave of the avant-gardes. These groups, along with today's associations of neo-classical painters, are now the main supporters of a renaissance of figurative painting. This movement is attuned to the present moment by adopting themes that are committed to the visual iconography of today.

1. *Adrià Llarch*, Portrait. *Oil on canvas.* The human figure is one of the most difficult challenges that an artist must confront.

2. Realistic painting requires a careful treatment of color and a love of detail.

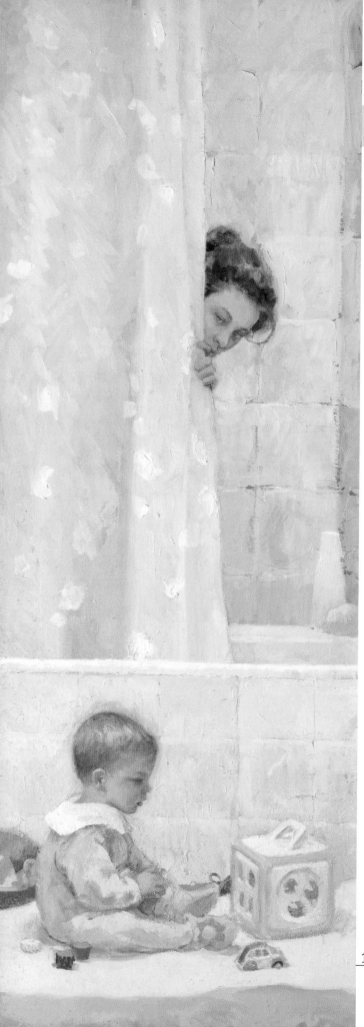

A NEW REALISM

There is a new movement of figurative artists who are using the traditional techniques of the old masters to paint new subjects. In their artwork, they've developed an iconography that belongs to the twenty-first century, which portrays current human experience in a display of sensitivity for those social issues that most affect us.

This realistic movement, with its clear contemporary mission, emerged as a strong reaction to the "anything goes" momentum of the neo-Expressionist art of the 1980s and as a reaction to postmodernism as well, and remains clearly dominant in the art market today. Neorealism represents a small fraction of all contemporary artistic production, but its practice and affiliation is spreading steadily among young creators. Its growth is flourishing due to the support of the many art academies and museums that have emerged in major Western cities in recent decades. Currently, realism is based on the representation of characters, environments, and landscapes typical of this contemporary era. Its range varies from the suggestive image to photographic detail. It encompasses several trends: hyperrealism, photorealism, or even magical realism; all having the clear aim of representing realism but with notable expressive and interpretative differences.

Contemporary realistic paintings are often astonishing, not only for their high-quality of execution, but also for their often-sophisticated, personal interpretation of subject matter. Despite being realistic works, many artists show an eagerness to modify reality while employing a personal style. This personalized vision reinforces the beauty of the representation and renders a forceful and powerful result. The transformation of light, strengthening of contrast, alteration of colors, and drawing to achieve a well-structured composition results in works that has can seem to have more life than the actual subject.

1. Mercedes Gaspar, The Bath. *The format, the framing, and the chromatic environment of the scene take on special importance in current realism.*

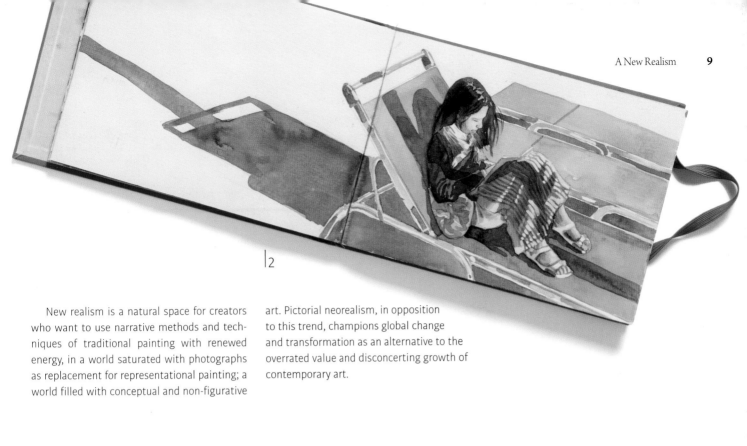

|2

New realism is a natural space for creators who want to use narrative methods and techniques of traditional painting with renewed energy, in a world saturated with photographs as replacement for representational painting; a world filled with conceptual and non-figurative art. Pictorial neorealism, in opposition to this trend, champions global change and transformation as an alternative to the overrated value and disconcerting growth of contemporary art.

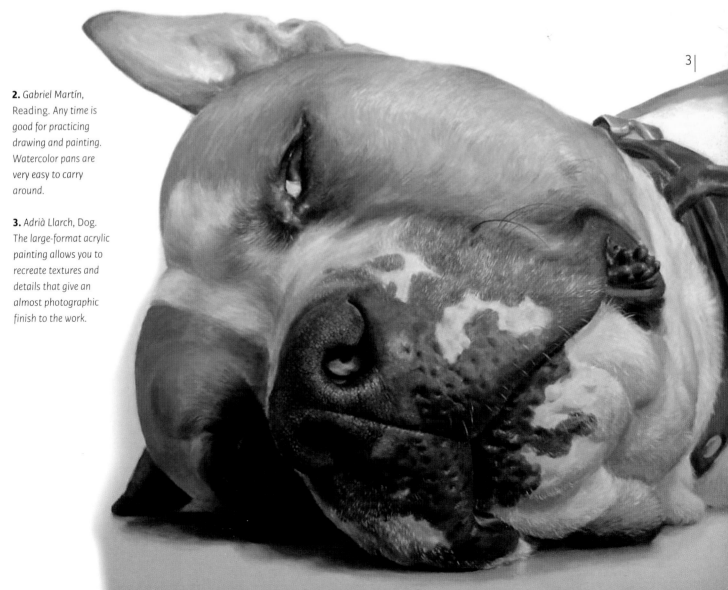

3|

2. *Gabriel Martín, Reading. Any time is good for practicing drawing and painting. Watercolor pans are very easy to carry around.*

3. *Adrià Llarch, Dog. The large-format acrylic painting allows you to recreate textures and details that give an almost photographic finish to the work.*

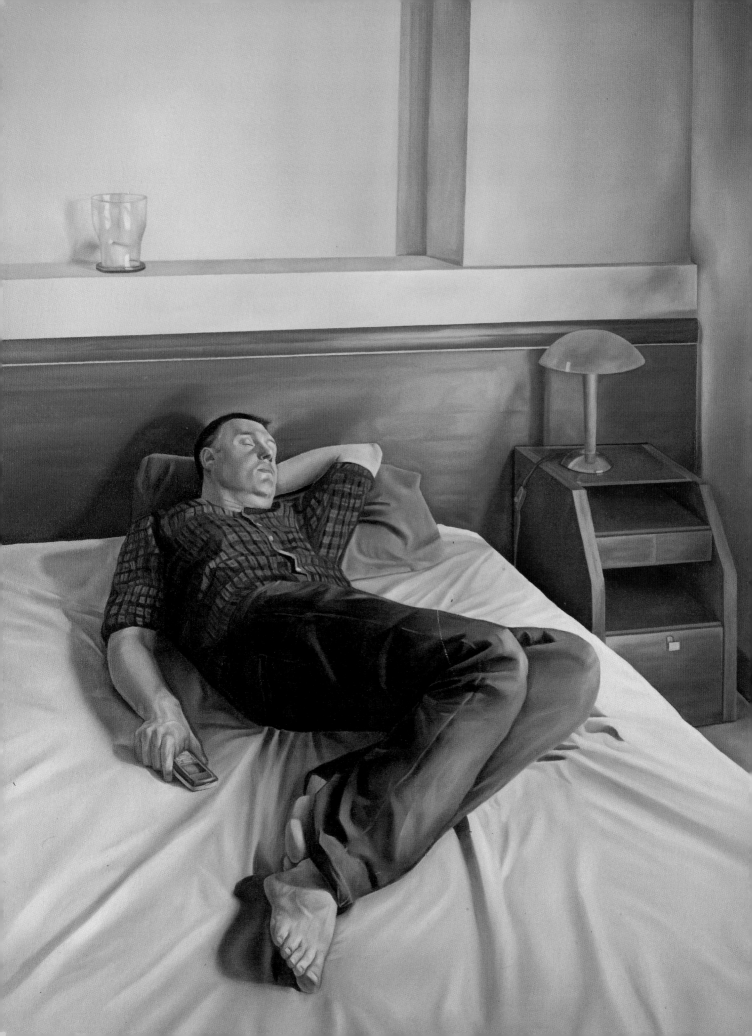

New Keys of Realism

The resurgence of figurative painting with its strong realistic component springs from the revitalization, restoration, and recognition of the artist as artisan; its champion is the easel painter, whose work involves both the mastery of drawing and the act of painting. Contemporary artists are re-inspired to continue the exploration of painting as a universal and inexhaustible language. While many choose a traditional path with respect to the use and execution of technique, they also pursue a very modern view that is distinct from the ideas of the great masters. Traditional and contemporary are two distinct aspects of painting that can comfortably coexist. A naturalistic and academic-looking painting can be both contemporary and committed to reflecting a society in which it must live.

Alberto Gutiérrez,
Figure in an Interior.
Oil painting.

THE RESTORATION OF THE ATELIER SCHOOLS

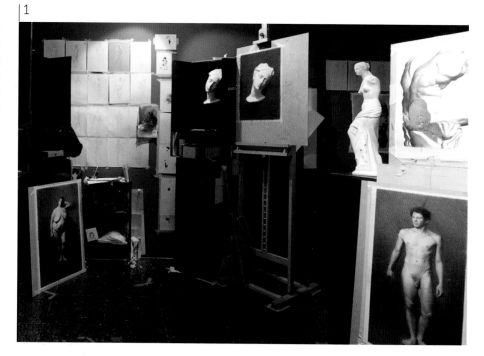

1

The early twenty-first century is witnessing a renaissance of humanism in the field of traditional painting; it is an expression of the human spirit and a legitimate contemporary art form that is capturing an increasing share of the art market.

Academic Education

The resurgence of realism encourages young artists to enthusiastically pursue traditional painting techniques. Academic teaching skills and the values of traditional painting have been reestablished by some art schools based on the teaching methods of the classical atelier. These teachings include the pedagogical methods that emerged during the seventeenth century and which then became established benchmarks for teachers such as Joshua Reynolds, Thomas Lawrence, John Singer Sargent, and in particular Jean-Léon Gérôme, Leon Bonnat, and Carolus-Duran. The philosophy of these painters, which underlies the academy's curriculum, promotes a return to the direct study of nature and to the old masters as the foundation and the point of reference of artistic knowledge.

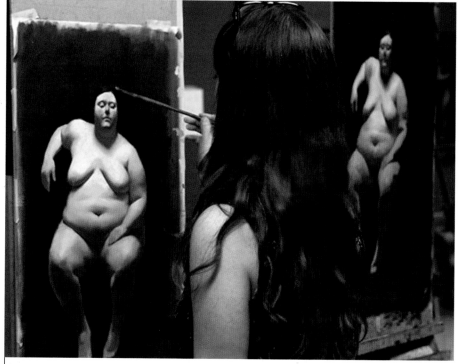

2

1. Atelier schools offer a complete curriculum based on teaching methods derived from the classic-realistic tradition.

2. In the ateliers, students of different levels and with very diverse backgrounds work together. All the students learn at their individual pace, while a tutor adapts various critiques to the progress of each individual student.

Expansion of atelier schools

Unlike conventional art schools, atelier or studio schools focus exclusively on representative art. One of the most important of these is the Angel Academy of Art in Florence, Italy. Since 1997, this school has taught students classical painting methods developed over the last six centuries as embodied in the work of the great Renaissance and Baroque painting masters. Over the years, the Angel Academy of Art and other schools throughout European and American cities have become hubs for artists who love representative painting. These academies have made it possible for people with a similar interest to gather together to share their knowledge, experience, and appreciation for representative painting.

3. *The program is focused and disciplined and requires artists to take one or two years of drawing before beginning to work with color. The main object of study is the human figure.*

4. *In the atelier schools, students develop a solid foundation in drawing.* Iago Remacha, Male Nude.

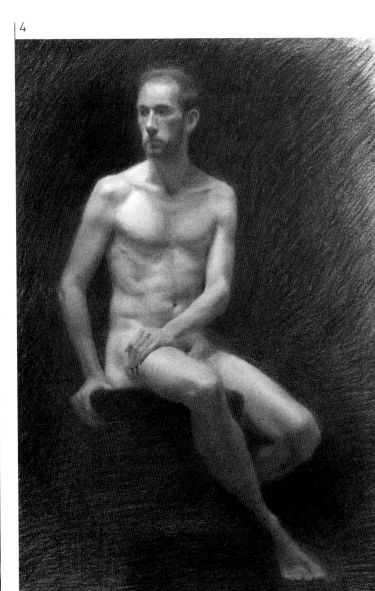

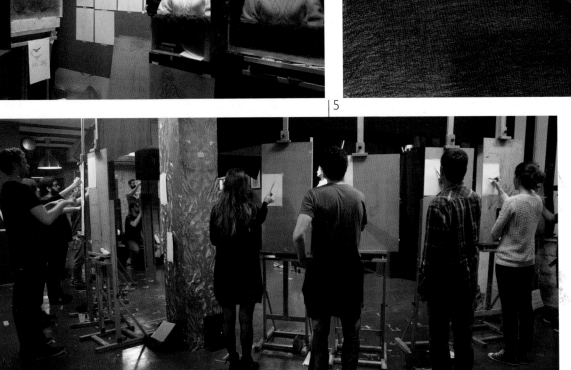

5. *Live drawing session at the Barcelona Academy of Art. This school is not a preparatory art school but a specialized institution in the field of figurative painting as practiced today.*

COMPOSING WITH THE SIGHT-SIZE METHOD

The term "Sight-Size" refers to a drawing method based on the observation and close study of the model to create accurate and realistic drawings. This teaching method seeks to produce a precise rendering of the live model with respect to the finished work of art. The purpose of this method is training the eye to clearly see differences between model and representation without the use of measuring tools.

Requirements for working with the Sight-Size method

This work method has a few requirements. First, the drawing board must be strictly vertical. The artist should always be located in the same position with respect to the drawing board and the live model so that both may be observed simultaneously for the sake of comparison. If working from a photograph, the format of the photograph should be as large as the drawing board for ease of comparing the image with the drawing being rendered. It is recommended that the artist mark the ground for placement of the feet to reinforce working posture discipline. One of the difficulties in following this method is the need for space as it can take several days to finish a drawing, especially when first learning the method.

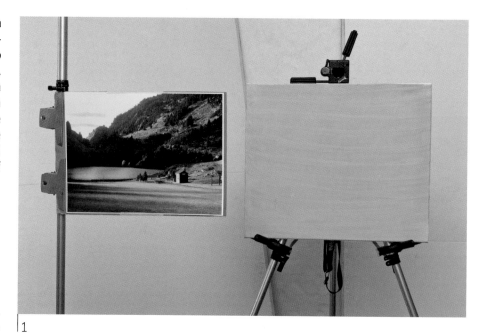

1

1. *It is preferable to work from life, but if the model is a photograph, it should be the same size as the painting.*

2. *The Sight-Size method requires working with enough space to be able to step far enough back from both the actual model and the artwork to check the progress as you go.*

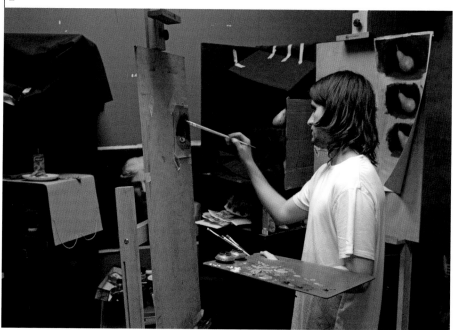

2

| 3

3. *Making a plumb line is simple. Tie a metal object that has some weight to the end of a piece of string so as to be suspended when the other end of the string is held.*

4. *The taut string will provide a perfectly straight vertical line that should overlap the model to calculate distances and transport these distances to the work surface.*

5 |

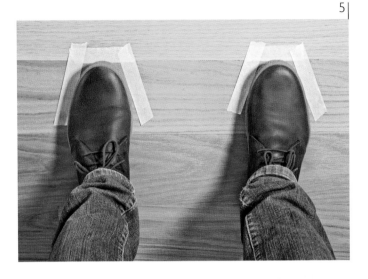

Work process

The draftsman must step back some distance to be able to see the work surface and model simultaneously. The model is studied carefully, and then the draftsman moves forward again to work at the drawing position. Measuring tools may be used initially to determine compositional lines and to calculate distances and relative sizes. Such a tool might include a plumb line, which is simply a weight tied to a piece of string. The plumb line is used when becoming familiar with measuring and composition, but with practice, this and other tools will not be needed. This is an important point: ultimately one must be able to memorize shape and draw from memory.

5. *To be sure the model is always observed from the same point of view and at the same size, the position of the draftsman's feet should be marked on the studio floor with pieces of masking tape.*

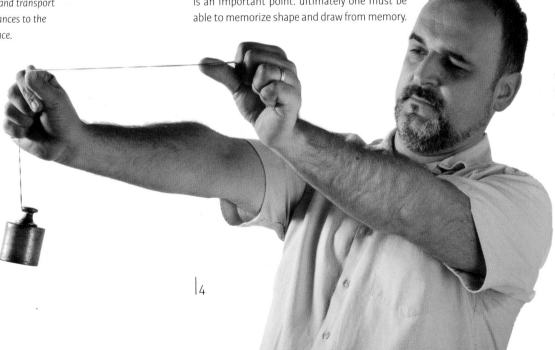

| 4

HOW TO SELECT A SUBJECT

One of an artist's most important skills is knowing how to select a subject. This skill requires well-developed abilities in observation. How does one choose between one subject and another? Among other factors, it comes down to the fundamental goal of rendering beauty, and to both surprise the viewer and connect with him or her through an image.

Actual or photographic model

There are two ways of working: from life or from a photographic reference. Most realistic artists prefer drawing from live models, but if working from a photograph is chosen, then it is best to use digital photography. Digital technologies allow fine control of the subject for cropping or zooming in, adjustment of light-and-shadow, and color saturation. Many artists enjoy working with photographic images and use them as subjects for painting.

1

2

3

1. *The selection of a model and the model's pose is critical. In painting today, the model does not pose impassively. The aim of painting is to explain an action or tell a story. Work by Gabriel Martín.*

2. *Creativity is portrayed through framing, cropping, featuring unusual points of view, or modifications of the chromatic range.*

3. *Some subjects, such as urban landscapes, are in themselves suggestive of contemporary settings.*

History, variety, and creativity

To successfully select a subject for painting, it is of primary importance to consider the image not simply as a straightforward photographic representation. It must tell a story or describe a situation through the artist's unique interpretation. No matter how beautiful the landscape, or how well lit a figure might be, if the composition does not offer a new way of seeing or a unique method of framing the subject, it will seem derivative and boring instead of exciting and appealing.

| 4

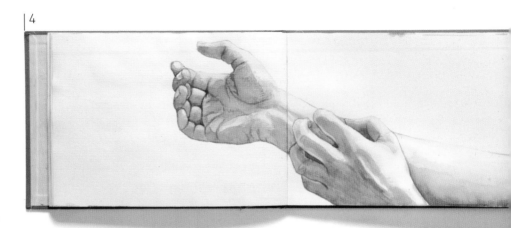

4. *The goal is to draw attention with something extraordinary such as unusual framing or crops and points of view. Work by Gabriel Martín.*

5. *Modernity is expressed by the choice of urban views showing contemporary buildings viewed from a foreshortened angle.*

6. *The inclusion of textures or highlights in the foreground aims to engage the viewer by providing a glimpse of photographic reality.*

| 5 6 |

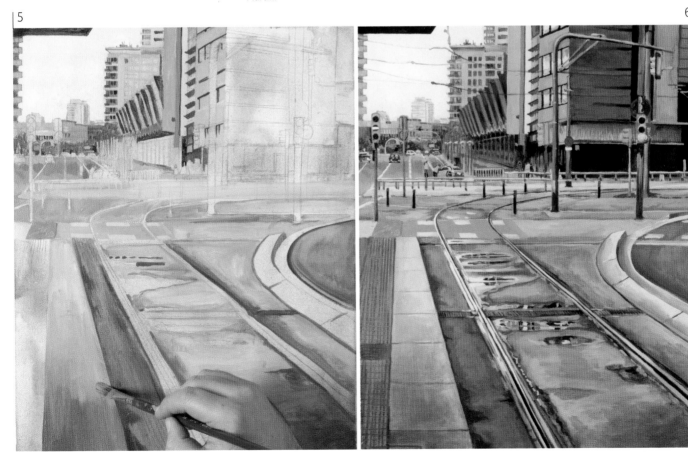

DRAWING AS THE BASIS OF REALISTIC PAINTING

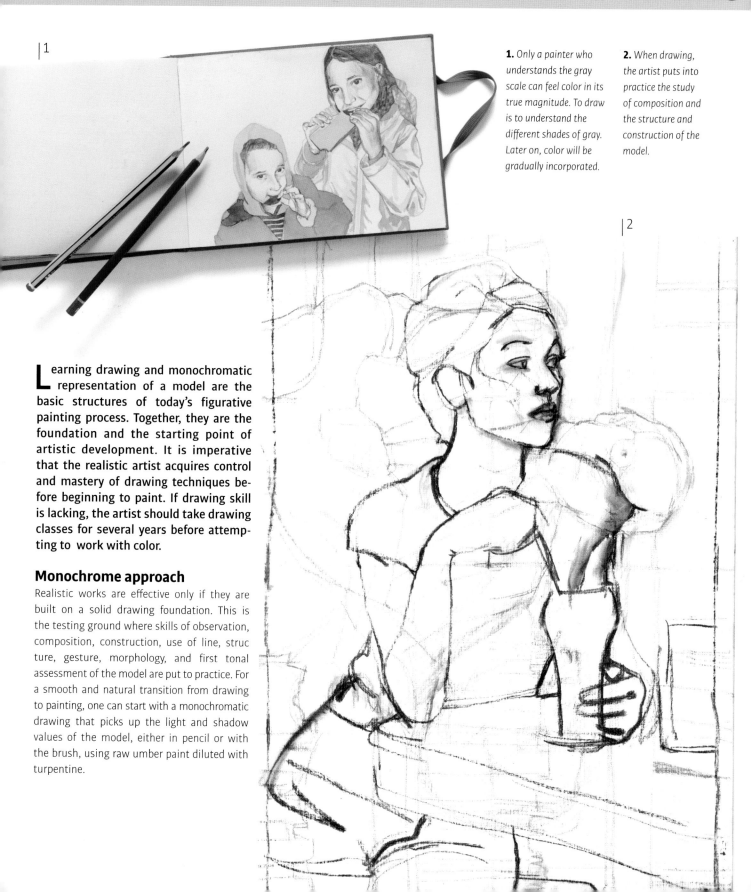

|1

1. *Only a painter who understands the gray scale can feel color in its true magnitude. To draw is to understand the different shades of gray. Later on, color will be gradually incorporated.*

2. *When drawing, the artist puts into practice the study of composition and the structure and construction of the model.*

|2

Learning drawing and monochromatic representation of a model are the basic structures of today's figurative painting process. Together, they are the foundation and the starting point of artistic development. It is imperative that the realistic artist acquires control and mastery of drawing techniques before beginning to paint. If drawing skill is lacking, the artist should take drawing classes for several years before attempting to work with color.

Monochrome approach

Realistic works are effective only if they are built on a solid drawing foundation. This is the testing ground where skills of observation, composition, construction, use of line, structure, gesture, morphology, and first tonal assessment of the model are put to practice. For a smooth and natural transition from drawing to painting, one can start with a monochromatic drawing that picks up the light and shadow values of the model, either in pencil or with the brush, using raw umber paint diluted with turpentine.

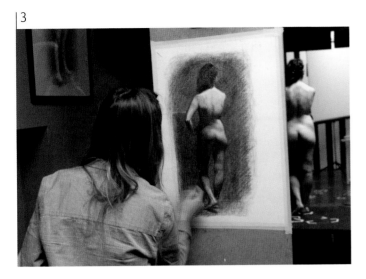

A well-worked drawing

The focus of constructing a drawing is based on calculating measurements from all points of the model. This includes understanding the shape as a whole by making a few basic lines, then deepening tonal assessment and defining precise shapes and contours. The strength lies in the overall vision and the subordination of detail. To apply color accurately and confidently, the preparatory drawing must be well finished. Such finishing includes tonal assessment and modeling to "feel" shape, define volume and light, and, if possible, generate an initial and tactile impression of the model.

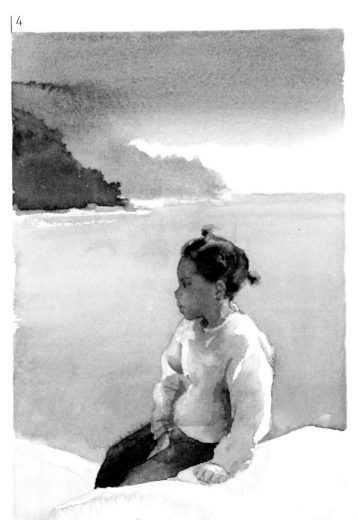

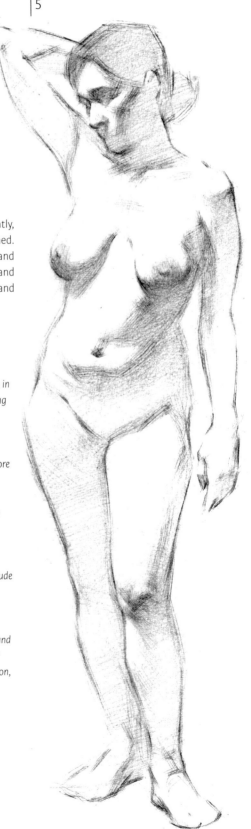

3. The success of realistic painting lies in consolidating drawing skills first.

4. To "feel" the color, you first have to ignore it and learn to work comfortably with a grayscale. Mercedes Gaspar, Girl.

5. The drawings include an initial evaluation of the model, which permits a better definition of shape and a first impression of volume. David Masson, Nude.

TONAL STUDIES

Charcoal is used to sketch out the basic forms and proportions of a model. This phase of the work requires focused concentration for as long as is necessary to ensure that the drawing is properly constructed. Anything that is visually bothersome should be removed or corrected. The artist cannot fail at this and becomes as an architect building the structures of the work. To finish, the charcoal drawing is rubbed with a rag to remove unnecessary lines before applying the first paint strokes.

Diluted staining

If artists are highly skilled in drafting they can perform these steps directly with a brush loaded with paint that has been well diluted in turpentine. The first strokes of the brush can be used to sharpen the drawing, fixing and incorporating the carbon particles of charcoal to the surface of the painting. The first monochrome staining, using either grisaille (shades of gray) or earth-color tones, is used to render volume. It isn't necessary to apply color just yet. However, depending on the paint brand used, raw umber may offer cooler or warmer shades. You must let the drawing sit untouched from time to time to observe it, critique it, and compare it to the original idea. A lack of confidence will be noticed immediately with excessive retouching.

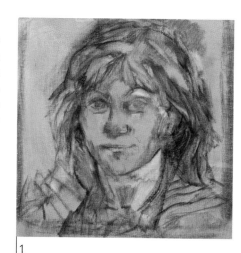

1

1. *The preliminary charcoal drawing can be softened with a rag or fixed with thinned paint applied by brush.*

2. *Before applying color, a monochrome model is constructed using earth colors, preferably raw or burnt umber.*

3. *The tonal work establishes the drawing with the first shading of the model.*

3

2

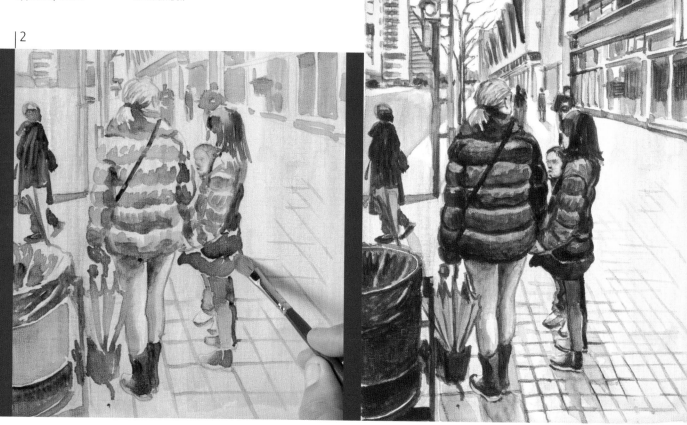

The black mirror as a drawing aid

Leonardo da Vinci, the great master of the Italian Renaissance, advised painters to use a black glass mirror (a small slightly convex mirror with a tinted surface) to discover imperfections in their drawings. When the work is viewed reflected and reversed in this mirror, it is easy to compare the drawing with the original model and from another perspective. The black mirror offers a more powerfully pure and defined vision of the drawing. The artist must stand facing away from the drawing and view it as if through a rear-view mirror.

4. *The black mirror is a fine critic as the reflection of the tonal drawing or study upon its surface shows possible flaws. It is a good tool for making corrections.*

5. *The purpose of using a single color in the preparatory sketch is to achieve a three-dimensional effect through shaded chiaroscuro (strong tonal contrast).*

6. *Different earth tones and burnt shades permit the rendering of architecture in stains of light and shadow. This will serve as a guide to the application of color and give volume and expression to the work.*

| 4

| 5

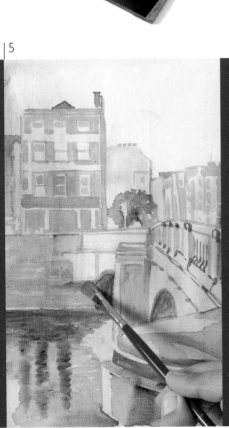

| 6

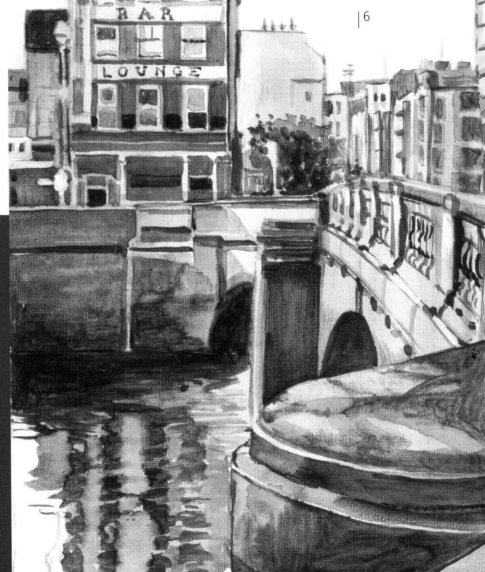

THE BASIC COLORS: PREPARATION

A well-grounded tonal drawing provides an excellent foundation for feeling, understanding, and approaching a subject's true colors. The goal is to paint the chromatic sensations of nature, sensitize the eye to express ourselves accurately, and adjust your color tones to the chromatic range of the subject to complete the illusion of realism.

Color desaturation

Most realistic painters are typically reluctant to work with pure color directly from the tube. Instead they prefer to mix colors to suit the tones of their subject matter. Pure color is often too saturated, so it must be desaturated to appear more natural and less strident. Desaturated colors are known as neutral colors. Any color can be desaturated by mixing it with a small amount of black, gray, white, or earth color. Another way to neutralize color is to mix it with its opposite or complementary color. Orange, for example, is desaturated by adding blue. Raw sienna is desaturated by adding cerulean blue.

1. Before starting to paint, it is best to prepare a few basic colors seen in the subject by mixing paint with a palette knife.

2. To calibrate colors to the subject, the palette knife is loaded with the relevant tone and the arm is extended over the subject to compare and adjust hue.

3. When painting realistically, saturated colors are rarely used. Artists choose different systems to desaturate color; you can mix saturated colors with neutral or complementary colors for different effects.

Palette preparation

Start by observing the subject and identify five or six main colors that define it. Next, prepare those colors on your palette by mixing them with a palette knife. To be sure a color is appropriate, the palette knife is loaded with a given color, which is then held next to the real or photographic model for comparison. These initial color mixtures are the base colors, the color chart of the painting, which will be shaded through the addition of other small and reduced mixtures applied by brush as the painting is developed.

Use of black

Today, many artists refuse to use black. But if white is used then why not also use black? Black, while a visible color, is often evident in chromatic variations and almost never in a pure state. In fact, strengthening denser shadows is achieved by adding black, but only as reinforcement, and while also paying attention to the temperature and variations of darker colors used in shadow.

4. *To desaturate a color it should be mixed with the color that is complementary and opposite to it on the color wheel. Such mixtures result in modulated color with modulated gradations, a goal in any realistic painting.*

5. *The most common method that artists use to desaturate a color is by adding white, black, or earth color to a pure color.*

6. *Grays and variants of whitened colors are also an option for desaturation, and also for the lightening of color.*

4

5

6

SURFACES, TEXTURES, AND HIGHLIGHTS

The color of objects and their surface qualities (rough, smooth, or textured) are varied and dependent on the type of light the object or surface reflects. Representing the tactile quality of different surfaces permits a truthful rendering of objects and materials. Successfully representing texture depends on capturing reflected light through the application of color variations. It isn't possible to explain how to paint all the shapes, textures, and highlights of different objects. There are no tricks or rules. But a few useful guidelines will aid in successfully painting the most common surfaces.

Polished metals

Polished metals do not have their own color but reflect elements or colors that are close to them. The effect of concave or convex metal surfaces is the distortion of the image of objects they reflect. The best way to represent reflections and highlights on metal is to apply bands of colors in varied widths.

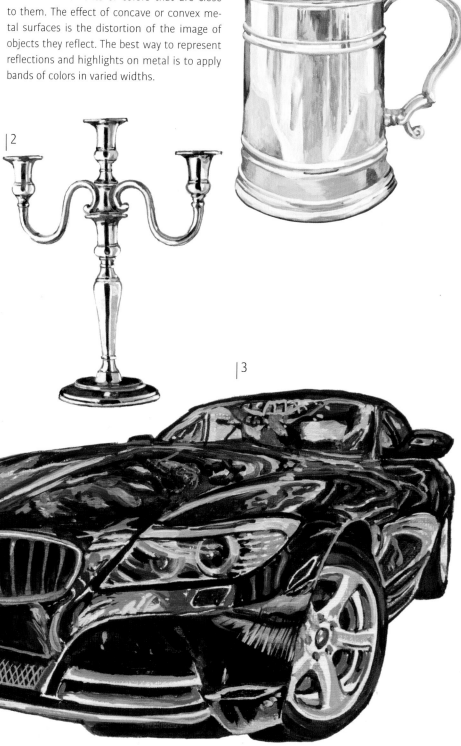

1. *The metallic shine of cylindrical or spherical objects is usually represented by the juxtaposition of several variously graded color bands.*

3. *The curved and polished surface metal of automobiles offers many reflections and highlights of objects that surround them. When a reflective surface is curved it alters the appearance of objects reflected in it.*

2. *Silver objects present a variety of reflections. Orderly distributing a range of soft grays strongly contrasted with fine black stripes can render silver objects.*

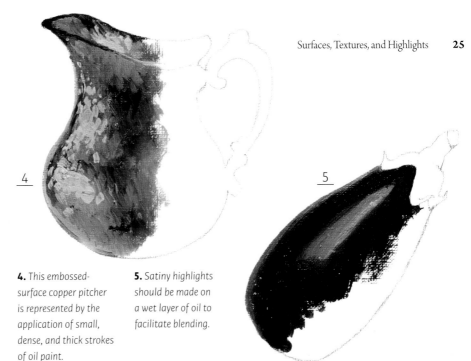

Rough surfaces

The best way to paint rough surfaces is to load the brush with relatively thick paint and apply it to the canvas with short, overlapping brush strokes. In this fashion the colors are carefully mixed on the painting surface as the subject is given shape, and the effect of a rough surface is created.

Glass

For glass objects, the final texture depends on factors such as background color and whether the object is smooth, curved, or tinted. With tinted glass there are many variations in tone. Darker colors are needed for contours and places where the glass is thick and more resistant to the penetration of light, such as at the base. In addition to transparency, pictorial quality also depends on surface gloss and whitened, detailed highlights that portray realistic expression.

4. *This embossed-surface copper pitcher is represented by the application of small, dense, and thick strokes of oil paint.*

5. *Satiny highlights should be made on a wet layer of oil to facilitate blending.*

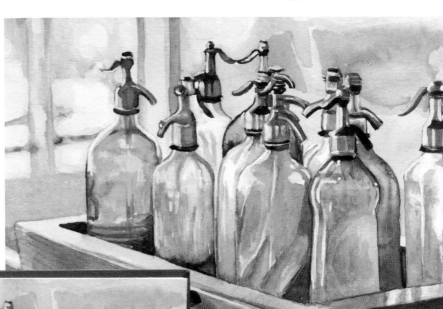

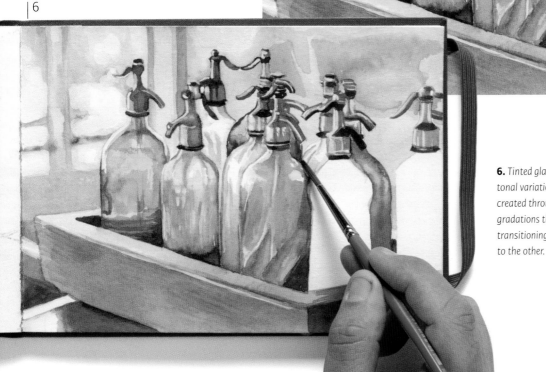

6. *Tinted glass offers tonal variations that are created through subtle gradations that fade in transitioning from one to the other.*

7. *The white highlights that have been preserved on the glass and metallic siphons convey the hard quality of the materials and their smooth textures.*

HOW TO DO IT:
WASHES AND HIGHLIGHTS IN WATERCOLOR

Here is a straightforward step-by-step exercise that uses watercolor to explore working with washes. The overlaying of fine color washes can result in an almost photographic representation of the model. Watercolor is a good media to overlay washes, and allows for representation in a realistic and subtle way. To avoid too many confusing details, the subject selected is a simple light bulb. However, a light bulb conceals great complexity in its highlights, shadows, transparencies, and reflections. To render it convincingly requires precise attention and great skill on the part of the artist. Painting by Gabriel Martín.

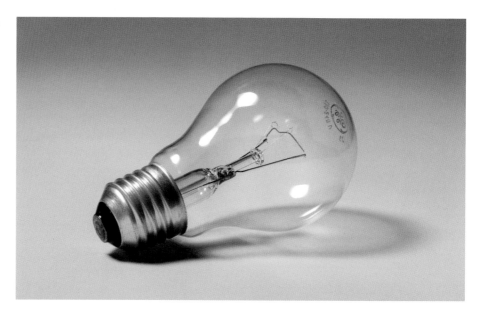

SUBJECT
The light bulb is placed on a light gray background. It is lit from an angle that enhances highlights and casts a slight shadow.

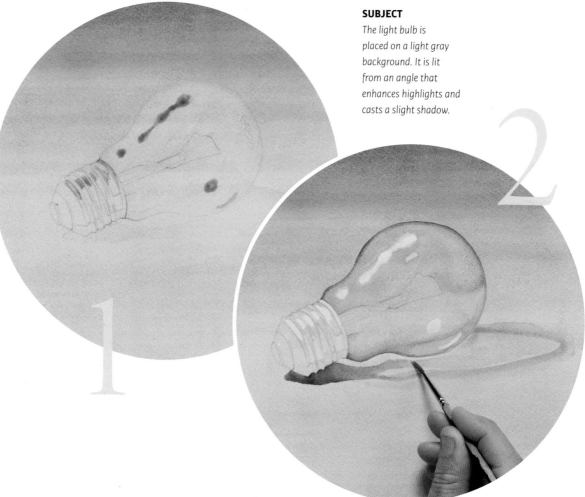

STEP 1
A latex gum masking fluid is applied to preserve the white of the paper where the highlights will be. Then the background is covered with a broadly stroked gray wash.

STEP 2
The contour line of the glass is defined with Payne's gray gradations. When the color is dry, the masking gum is removed to reveal the highlight. With that same color, but more diluted, the shadow is defined.

STEP 3

For metallic highlights, Payne's gray and a pinch of blue are mixed. The fine lines of the filament are reinforced with graphite pencil.

STEP 4

The shades of gray contrasting with the highlights must be clearly rendered on the metallic thread. With a very fine round brush, lines are drawn to better define the contour.

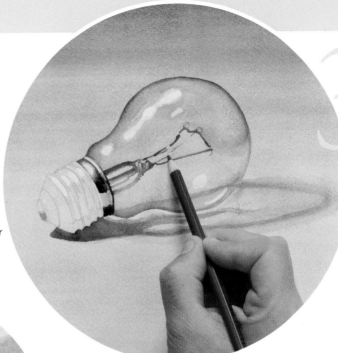

FINISHED STATE

Meticulous work and careful observation of the subject will lead you to discover small, closely seen details that will infuse your paintings with the feeling of realism.

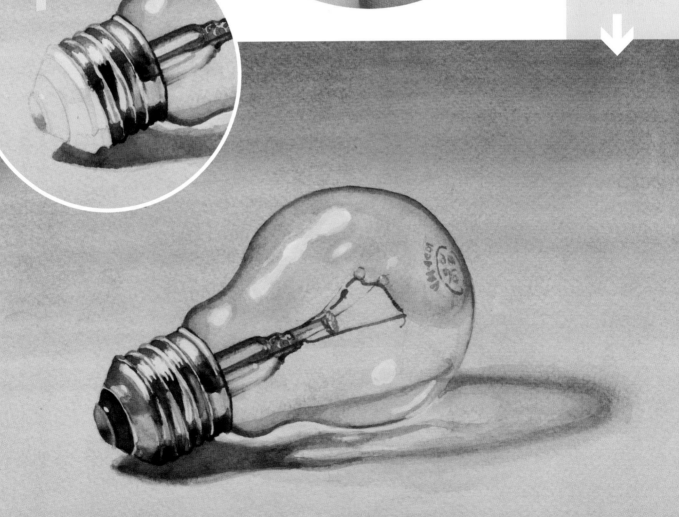

HOW TO DO IT:

METALLIC AND GLASS EFFECT IN OIL

The next subject is a little more complex than the light bulb in the previous exercise. To study metallic highlights and somewhat irregular shapes, a slightly wrinkled metal can is placed next to a drinking glass. These objects are arranged on a white tabletop. A neutral gray background helps focus our attention on rendering the composition and avoiding distractions. Oil paints are used, but we continue working with glazes. You can dilute the colors (and help accelerate drying) by adding a drying medium, such as a drying linseed oil or dammar glaze. To ensure proper drying of each color layer before adding others, we will work on different days. Painting by Gabriel Martín.

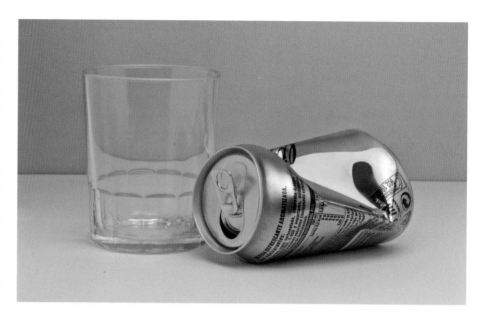

MODEL

These two objects are very different: one is transparent and the other has metallic highlights with hints of color.

STEP 1

After adjusting the pencil drawing, the first layer is made with a grisaille, a mixture of Payne's gray and titanium white.

STEP 2

To tint the initial grays, burnt umber is gradually added. The shape is built by adding lines with a thin round brush.

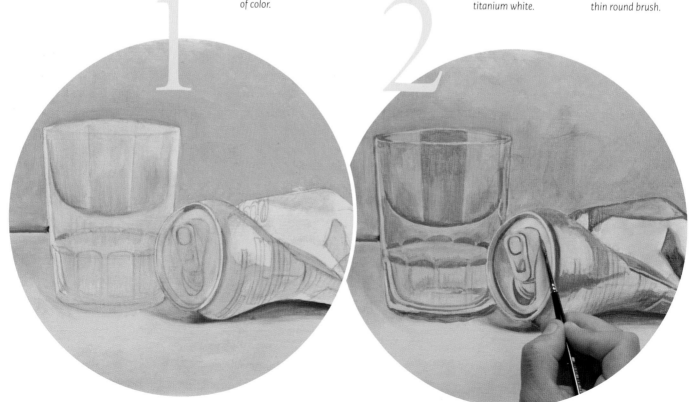

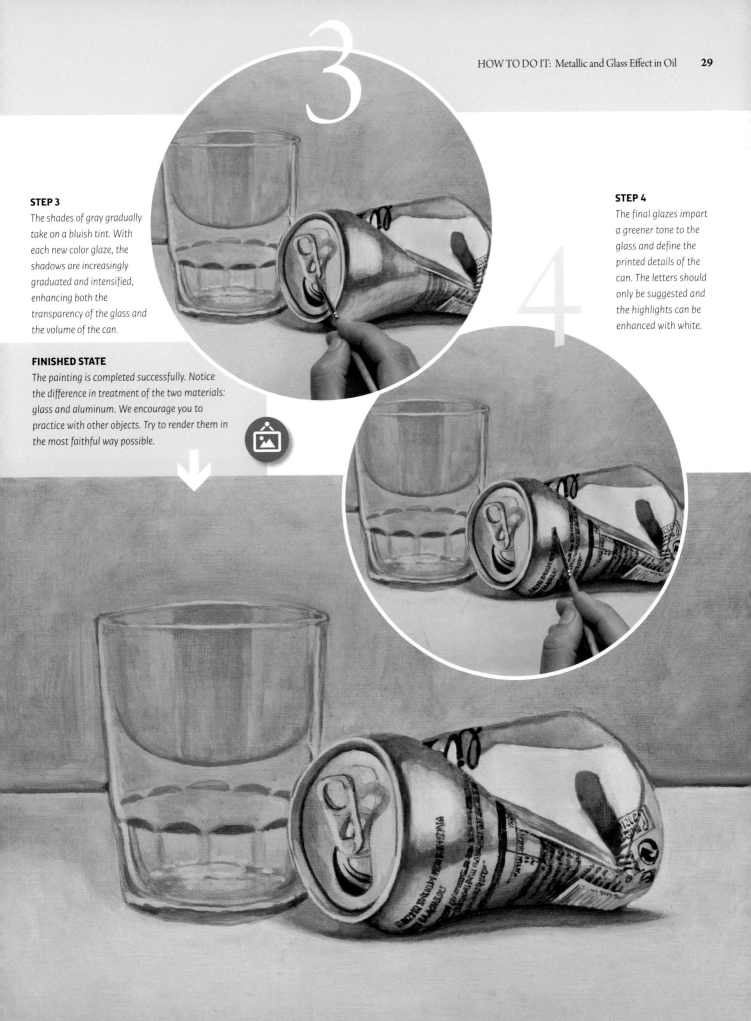

STEP 3

The shades of gray gradually take on a bluish tint. With each new color glaze, the shadows are increasingly graduated and intensified, enhancing both the transparency of the glass and the volume of the can.

FINISHED STATE

The painting is completed successfully. Notice the difference in treatment of the two materials: glass and aluminum. We encourage you to practice with other objects. Try to render them in the most faithful way possible.

STEP 4

The final glazes impart a greener tone to the glass and define the printed details of the can. The letters should only be suggested and the highlights can be enhanced with white.

GALLERY:

STILL LIFE, A GOOD PLACE TO START

Before dealing with complex genres such as landscapes or the human figure, it is important to practice building volume, color modulation, and rendering highlights and reflections. This is achieved by mastering the still life genre. Since a still life is static and lit with a controlled and contrasting light, the artist has time to focus, to analyze, and to study carefully without being rushed. Any corner of the studio is suitable for setting up a still life. This genre is flexible and allows for the incorporation of everyday objects and the use of surprising and improbably combined elements.

1 **Mireia Cifuentes, Apples.**
Oil on canvas.

It is possible to start this study with two simple elements built with dense brush strokes of oil paint. In building the fruit volume, the shading of the apples should be subtle. The cast shadows of the apples separate them from an unusual background where the tile color predominates. The interesting thing about this realistic painting is how brush-strokes are used to create atmosphere while promoting a blurred effect that softens the contrasts of the apples and gives them a more expressive look.

2 **Adrià Llarch, Still Life.**
Oil on canvas.

Contemporary realism in still life incorporates objects related to today's consumer society—a fruit juice carton, a handheld electronic game, a plate of cookies. This work presents an interesting contrast of twenty-first-century objects with a type of chiaroscuro illumination typical of the Baroque. The author intends to start a dialogue between tradition and modernity and to merge both concepts.

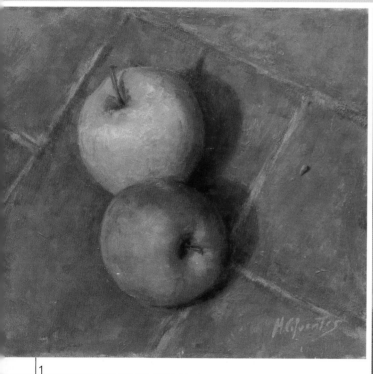

1

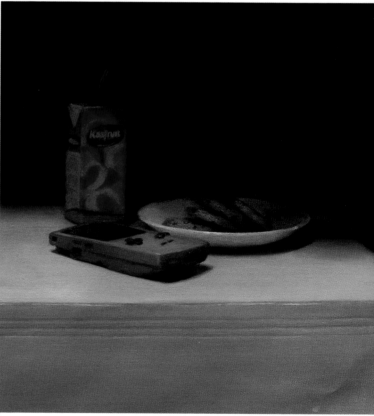

2

3 **Mercedes Gaspar, Still Life.**
Oil on canvas.

The recreation of different materials and varied textures is intrinsic to still life. The following setup provides a good opportunity for study and practicing the reflection of light on tiles, a glass bottle, a metal teapot, and a tablecloth. In each of these items the way light is reflected is completely different. One must learn to differentiate the soft gray gradients of glass, the thickly painted color bands of the teapot, or the subtle range of white on cloth.

4 **David Masson, Still Life with Skull.**
Oil on canvas.

This is an example of how to bring a still life to the greatest degree of realism. The keys are the light, the careful modeling of the skull, and the different surface textures of the cup and cloth. In the seclusion of a studio, under controlled light, the artist can work for days, even weeks, and reach high levels of detail.

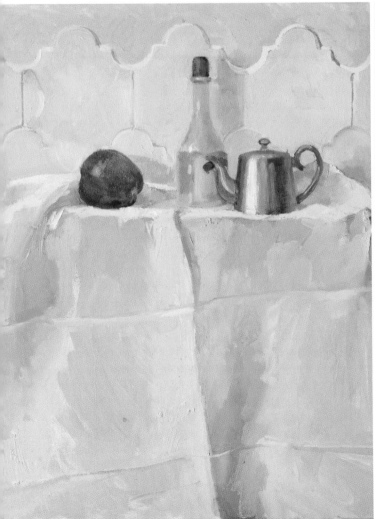

3

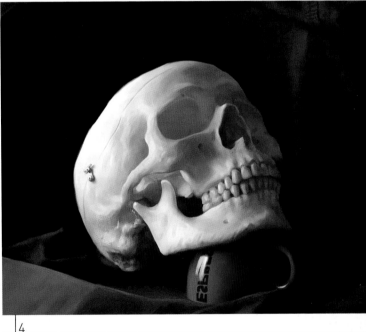

4

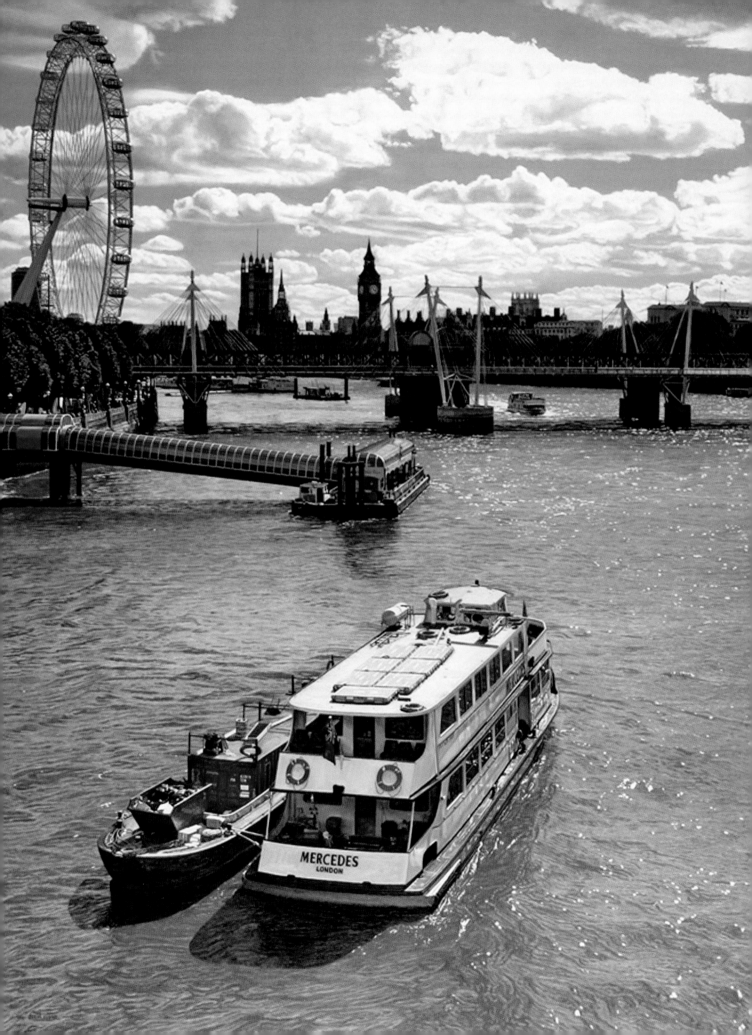

Realism in Landscapes

The easiest way to get started in realistic painting is through depicting either natural or urban landscapes. Natural landscapes offer fewer drawing challenges, although they requires significant color adjustments, principally in the wide range of the color green. Urban landscapes demand a rigorous adherence to perspective or the final result will seem askew.

The realistic landscape must be based on an accurate and confident view of nature or architecture. The painted scene should be stripped of all symbolism and become a neutral subject.

The representation must be pleasing to the eye, highlighting the textures of vegetation, the glittering surface of water, or the reflections in the facades of big city buildings.

Daniel Cuervo,
Mercedes-London.
Oil on canvas.

HOW TO DO IT:

TEXTURE OF ROCKS IN OIL

To first approach the realistic landscape we will initially look at one of its most characteristic elements: rocks or stones. For a subject we've selected a group of overlapping stones of different sizes and colors that cast shadows upon each other. Painting by Gabriel Martín.

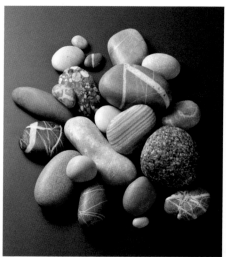
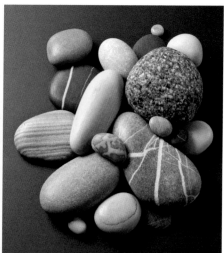

A very accessible subject

This exercise is simple to set up. You can either follow this exercise using real stones that you arrange yourself in your studioor you can work from a photograph: the choice is yours. The palette here was prepared with a selection of oil colors: violet, carmine, indigo, Payne's gray, burnt umber, white, and black. You can use a little Dutch varnish or drying medium to dilute colors and give them a more oily consistency. In addition to accelerating drying, this will also allow for the overlaying of glazes.

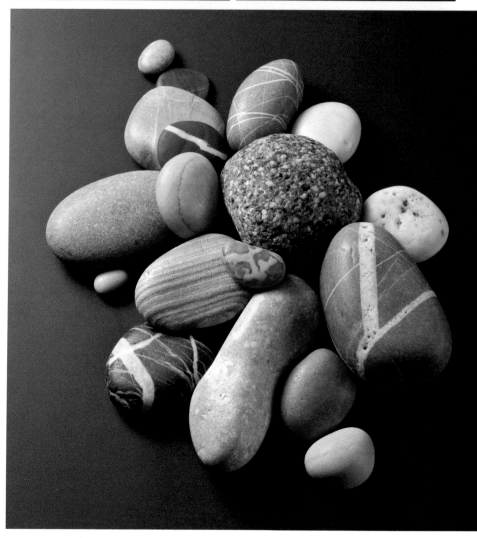

SUBJECT

A few stones of differing color and size are placed on a sheet of gray cardboard. A lateral light source creates an interesting play of light and cast shadows. Different arrangements should be tested before you decide on the final composition. The chosen arrangement should display balanced colors and smooth cast shadows.

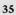

STEP 1

This drawing is one of the simplest in the book. It consists of sketching the outline of each pebble with a thin line that defines its shape.

STEP 2

Black, Payne's gray, indigo, and white are mixed on the palette to get different shades of gray with which to stain the background, which should be painted in a simple gradation—lighter on the left and deeper toward the right as it moves away from the light source.

STEP 3

Now it's time to work on the still uncolored rocks. Color is applied depending upon the hue of each rock and adding a little gray to the areas in shadow. The shadows are graduated and smoothed by applying repeated strokes with a soft-hair brush.

STEP 4

It's possible to re-create the three-dimensional feeling and roundness of the rocks with only two or three different shades. Lightened colors are applied to the section of rock exposed to light with grayer tones applied to the shadow area. The consistency of the painting should be dense. We are not working here with thinned colors.

Modeling exercise

The different coloration and texture provided by a mix of stones is good training for learning color modeling, rendering of three-dimensional round surfaces, and texture. Grouped stones are also ideal subjects for shadow work, as deep shadows between them enhance the three-dimensional relief effect.

FINISHED STATE

It is important to differentiate the surface texture of each rock. Thicker and denser brushstrokes convey the idea of roughness, while smoothness is rendered with the addition of highlights and blended modeling.

STEP 5

It is important to pay attention to both the texture of the stones and the colored veins and stains as seen here. The granite stone at the center was built of light dabs applied with the tip of the brush, alternating white, gray, and burnt umber.

STEP 6

The veins of the stones are not a uniform white color. They too must be graduated to match the rendering of shade and shadow. When diluting oil paint with medium, soft glazes can be applied to modify underlying layers of color.

STEP 7

As the color of the stones intensifies, shadows too must also be rendered more intensely for greater contrast and more precisely rendered contours.

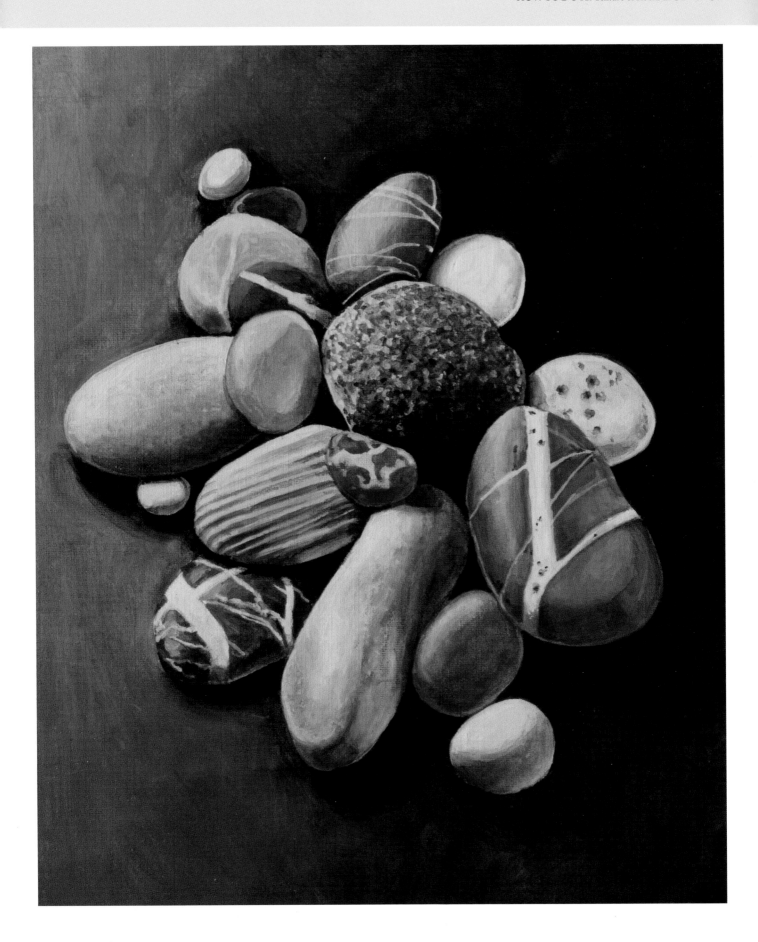

IN DETAIL: A CLIFF

This piece, painted in watercolor by Gabriel Martín, depicts a rocky cliff along a coastline. The granite formations, full of cracks, cavities, and wear, are a suitable subject to practice the rendering of texture and the tactile quality of rock surfaces. In this piece, detailing is the outstanding feature. Attention must be paid to light and projected shadows as well. They describe reliefs, depressions, and protrusions of the the rock surface.

1. Before working on the rocks, a gray-green wash is applied over the shaded areas of the cliff. With the water still damp, salt is sprinkled on the surface, which, when dry, will offer a cracked texture and serve as a basis to recreate the rocks.

2. In watercolor painting, salt is used to break the smooth and regular appearance of a wash to create texture.

| 1

| 2

3. Final highlighted touches are made with a touch of white gouache and a very fine round brush.

3.1. The paper is pre-moistened with water. Touches of cyan blue are then applied, which, upon contact with the wet surface of the paper, expand to form diffuse edges.

3.2. With a white oil pencil, the lines defining the foam at the base of the rocks are drawn. Then, with more saturated and pigmented watercolor, the water area is covered with cyan blue, Payne's gray, and some ocher, interspersed with a few short strokes that suggest the movement of the water surface.

3.3. To make the rocks, shading is applied first. Then the largest cracks are defined. Finally, the smaller color spots are applied to render texture, lichens, and oxidation, as seen in the variety of coloration.

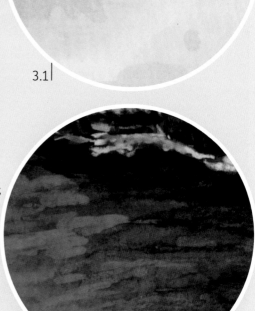

3.1 |

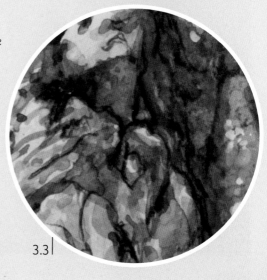

3.2 |

3.3 |

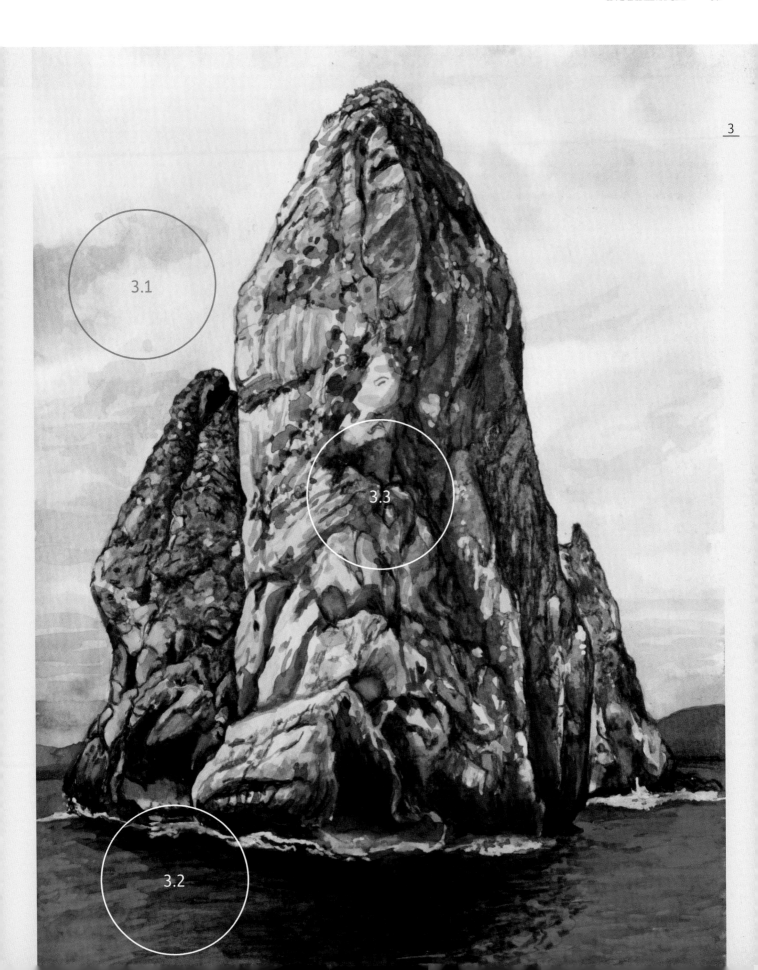

THE REALISTIC LANDSCAPE

It is always preferable to paint a landscape outdoors, but a realistic painting requires many hours of work while light and weather conditions change with the passage of time. It is just as acceptable to work in the studio from either large-format quality photographs that are a minimum of 8 x 10 inches (203 x 254 mm) in size—or, as many people do today, from a photograph on a digital screen or tablet. Painting by Iago Remancha.

Visual perception is key in the rendering of every landscape. This includes noting changes in light, color of vegetation, and consistency of detail. More distant planes should have lighter, softer, cooler hues. No matter how much you want to highlight mountains, the effect of detail or texture must be reduced.

SUBJECT

The subject is the landscape of a high mountain. The morning light causes an interesting chiaroscuro and suggestive effects of shadow projected upon the foreground field.

STEP 1

Before starting, the canvas is prepared. Small drops of burnt umber are strategically distributed over its surface.

STEP 2

With a folded cloth moistened with turpentine, the surface is rubbed vigorously to produce a stained white canvas and a colored base on which to easily work.

STEP 3

The canvas is placed on the easel close to your photograph. If you are just learning landscapes, it is ideal—as it facilitates the comparing of proportions—if your canvas and photograph are of equal or similar size.

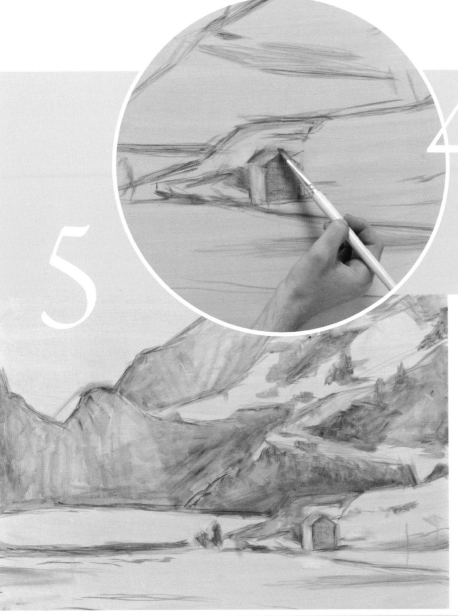

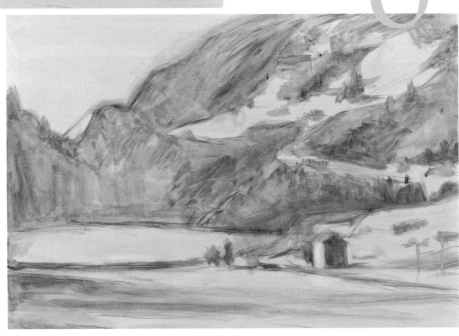

STEP 4

The preliminary drawing is done with a soft-haired brush loaded with very dilute burnt umber. The outlines are drawn first. It is advisable to work slowly and use the plumb line to accurately measure the angle and length of each line.

STEP 5

The lines made with the brush are completed with the appearance of the first shaded areas, which are also constructed in oil diluted with turpentine.

STEP 6

The initial shadows are very loosely rendered. Little by little they are better defined with the brush until the first phase of the painting is finished. This phase aims for achieving a monochrome representation of the subject, which will serve as a basis for the subsequent application of color.

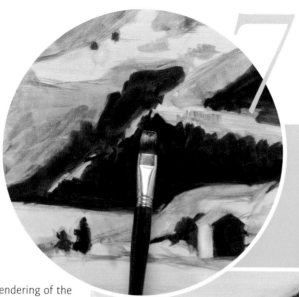

STEP 7

The result of mixing burnt umber and cobalt blue is a dark neutral color used to create the deepest contrasts of the mountain slopes. Attention to detail at this stage is not necessary and applying some stains is all that's needed.

Preparation of colors

Once the initial monochrome rendering of the scene has been achieved, the palette is prepared with the colors needed to paint the picture: a bit of burnt umber, cobalt blue, English red, yellow ocher, cadmium yellow, and titanium white. The mixture of these colors is enough to render all the chromatic variations present in the photograph. Next to the palette is a cup with turpentine to dilute paint and make it more fluid, and another cup with linseed oil to make glazes.

STEP 8

Bluish-gray spots of color are applied to the darkly shaded areas. A soft green is applied to the background mountains and the foreground meadow.

STEP 9

A variety of greens are created by mixing cadmium yellow, cobalt blue, and a pinch of ocher. They are then used to cover the meadow grass. Greens that describe the shadows cast on the field are created with a smaller amount of yellow, as can be seen in the video accompanying this exercise.

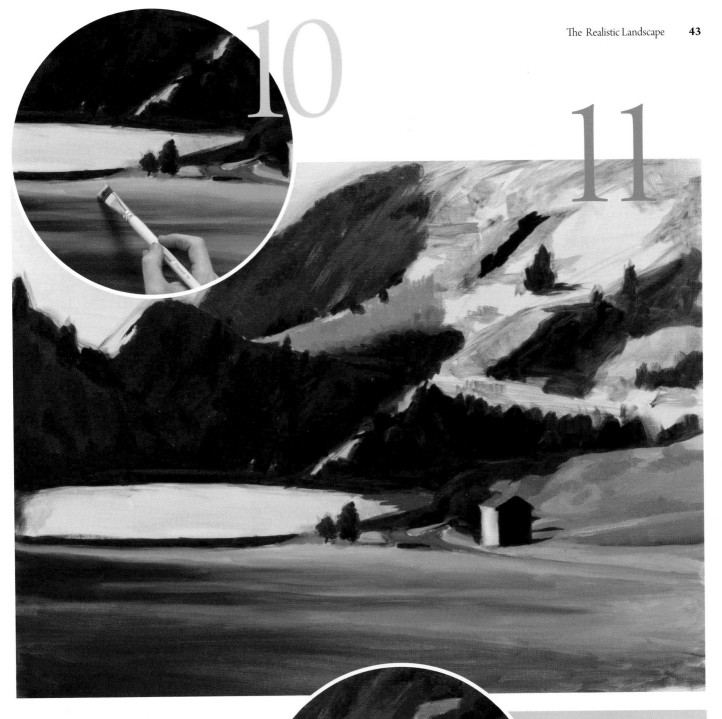

STEP 10

It is best to work with soft-hair brushes and apply the brush strokes by moving your arm horizontally. This permits areas of light and shade to blend and gradually fade..

STEP 11

Once the foreground has been stained, the intermediate planes are worked up to give shape to some trees and highlight the gray path. The first blue spots are added to the lake. As much as is possible, adjust your paint mixtures to the original color of your photograph.

STEP 12

The lake is filled in with a mixture of cobalt blue, titanium white, and a pinch of burnt umber, which desaturates the strength of the blue. The upper part of the mountain slope is stained with different shades of dark green and purplish gray, as is shown in the video.

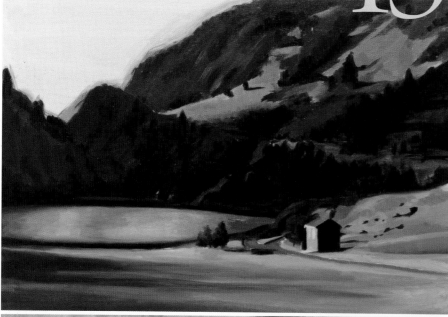

13

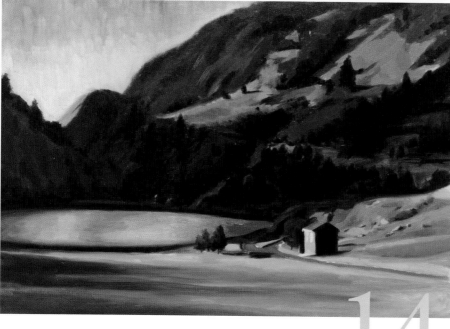

14

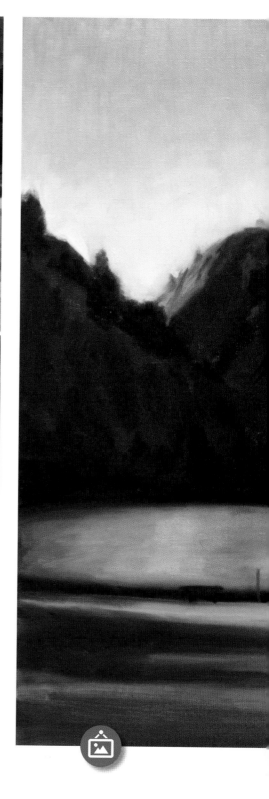

STEP 13

Burnt umber mixed with intense green is used to paint some middle-ground firs, to render some shadows in the groves, and to suggest the position of some rocks behind the house. The house is painted with uniform strokes creating shadow and light.

STEP 14

The sky is painted with the same blue tones used on the lake, forming a gradation from lighter on the horizon and darker toward the top. In this case, the direTction of the brushstroke is vertical and upward. Body is given to the rocks next to the house using a medium gray.

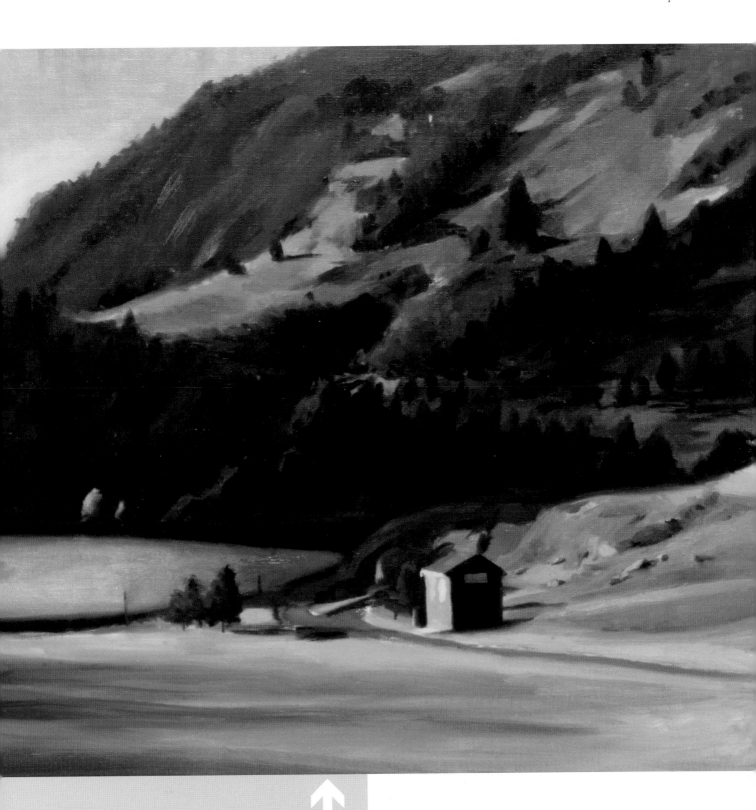

FINISHED STATE

The finished work masterfully captures the interesting set of lights and shadows projected onto the landscape. The shaded areas, richly valued with a multitude of shades, make it possible to perceive the vegetation and rocks that hide there.

HOW TO DO IT:
DEW DROPS IN ACRYLIC

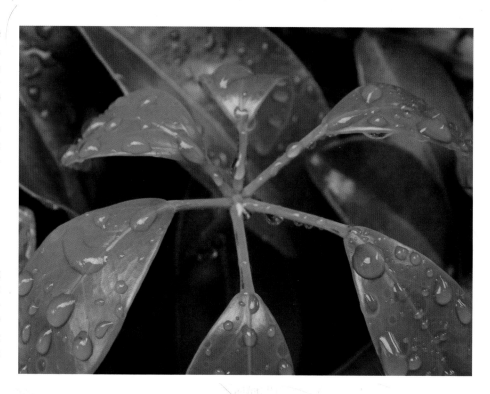

To paint a landscape, it is advisable to know the component elements, which usually consist of rocks, water, clouds, and vegetation. In previous exercises we have seen that a good way to approach a landscape is to isolate elements and study them from a meticulous and almost scientific representation with regard to texture and lighting characteristics. Painting by Isabel Pons Tello.

The versatility of acrylic

This set of leaves, still covered with morning dew, provides an interesting play between transparencies and light reflections. The technique used is acrylic paint, which allows for working with transparent washes in the first phase of the exercise, then subsequently, with paint that is more dense and opaque.

SUBJECT

The reference is this group of leaves bathed with dewdrops. They offer an interesting geometric arrangement and add highlights to the composition.

STEP 1

The format is small so the drawing is done with a mechanical pencil. First, the contour of the leaves is well drawn, a slight tonal-shading is added, and the water droplets defined.

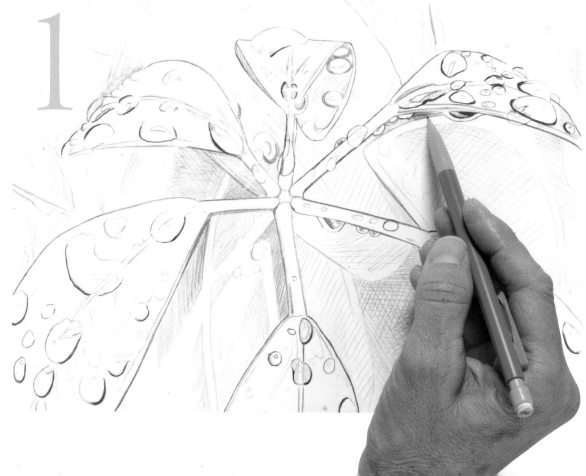

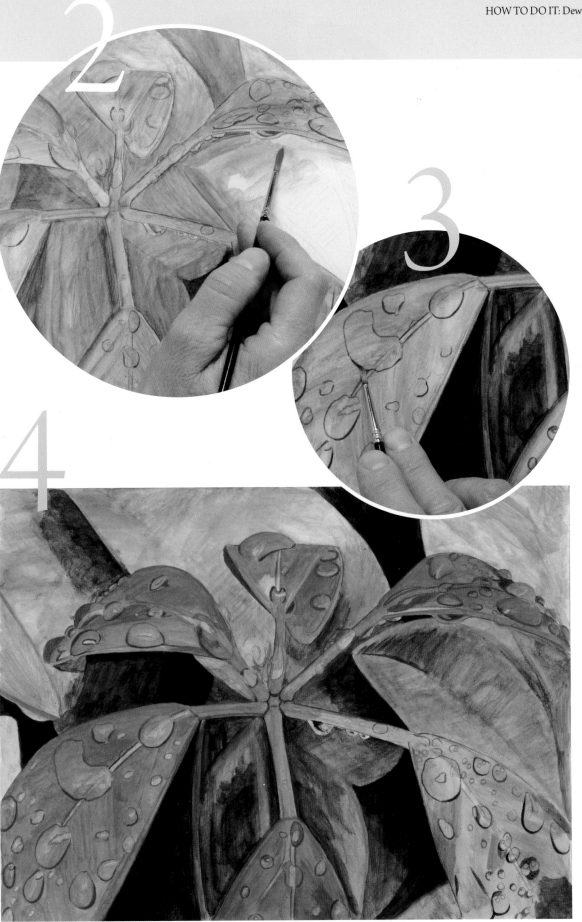

STEP 2

Working with diluted paint, the white of the paper is covered with permanent green and sap green. Using these two tones, the goal is to differentiate the foreground leaves from those in the background.

STEP 3

We mix emerald green with a little bit of black. This results in an intense green that is applied on the shaded areas of the background, creating color gradations. With this same color, applied by brush, the drops are drawn.

STEP 4

Permanent green lightened with yellow is used to cover the leaves and stems at the center of the picture. The work is done carefully, taking into account the changes of surface value. Small spots on each drop are preserved, uncovered, with this layer of paint.

The challenge of painting the drops

Since water is transparent, the only way to represent drops in this scene is to highlight the effects produced by light. The shadow at the base of each drop is drawn with a thin line, and a strong highlight is used to render the brightness of reflected light. This is enough to represent the effect of dew on the leaves.

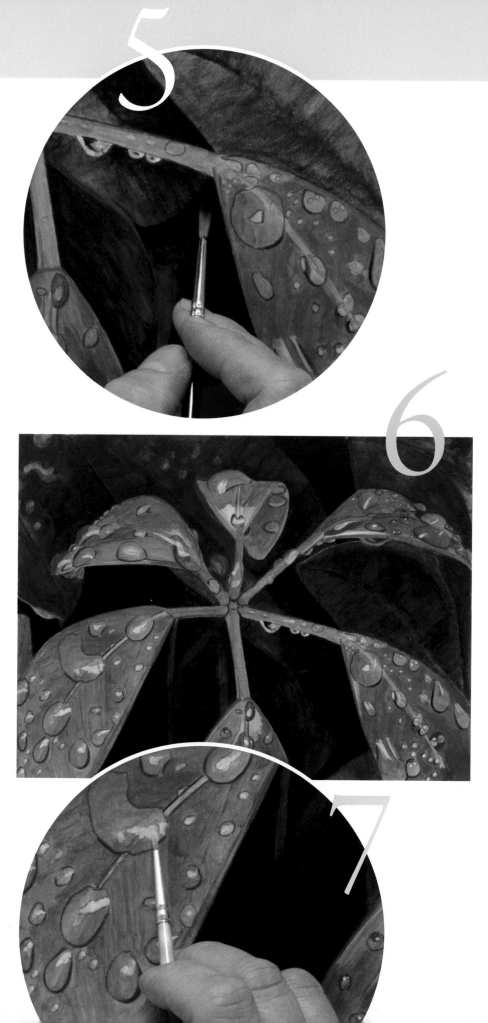

STEP 5

As the foreground takes shape, the background is completed with new acrylic glazes that enhance contrast and give the scene more depth. At this point the pencil lines have disappeared under the layers of paint.

STEP 6

The background leaves should appear dark and in slight contrast with an even darker background. The tone of these leaves should enhance the central group of leaves, painted with a warmer and yellowish green. Some titanium white highlights are added on both leaves and drops.

STEP 7

Each drop should have a detailed and intense white highlight, which, together with the dark line that defines the base, produces a realistic effect.

STEP 8

The whites of the leaf surface are translucent and blend into the green color using linear strokes that highlight the smooth and shiny surface of the leaf. White highlights are effective when applied in specific spots on a leaf and not over the entire surface.

FINISHED STATE

The finished work acquires an almost photographic appearance that does not depend, as might be thought, on the quantity of detail but on the precise control of surface light effects.

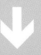

HOW TO DO IT:

THE TEXTURE OF VEGETATION

When painting a realistic landscape in watercolor, the first areas of applied color are different than when oil or acrylic is used. Since watercolor is a transparent medium, dark colors should not be used initially as applied highlights will not be seen.

Going from light to dark

It is necessary then to work with very light and watery base colors. While these colors mute the brilliance of white paper they will not adversely affect subsequent color layers. Such layers will overlay each other to portray both the leaf texture and the grass covering a field. Painting by Gabriel Martín.

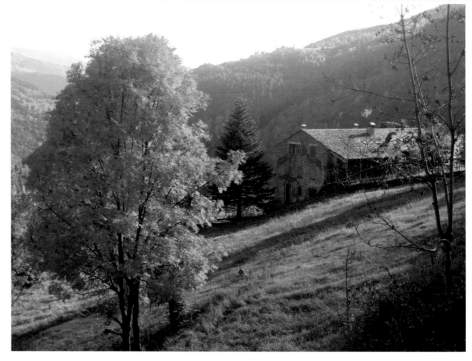

SUBJECT

The subject is an alpine landscape. A tree in full foliage appears in the foreground and is ideal for working with texture.

STEP 1

The drawing is carefully executed in pencil. It must provide a linear outline and accurately describe the profiles of the elements. The first watercolor washes are very transparent.

STEP 2

While foreground washes are drying, new washes are superimposed on the background. It is preferable to render the more distant mountains as soon as possible.

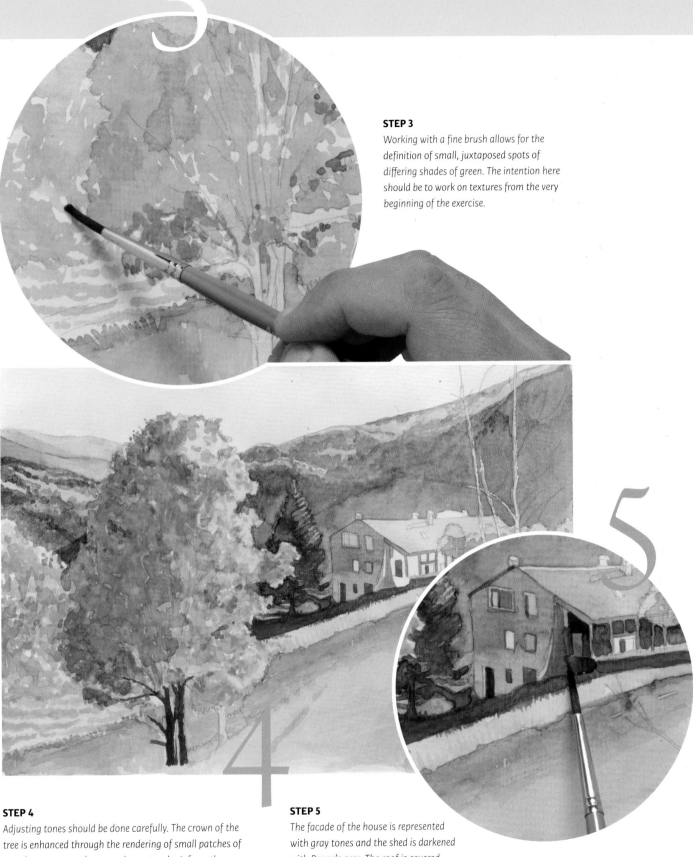

STEP 3

Working with a fine brush allows for the definition of small, juxtaposed spots of differing shades of green. The intention here should be to work on textures from the very beginning of the exercise.

STEP 4

Adjusting tones should be done carefully. The crown of the tree is enhanced through the rendering of small patches of translucent greens that complement and reinforce those painted previously. The spruce and grass near the house require a much darker green.

STEP 5

The facade of the house is represented with gray tones and the shed is darkened with Payne's grey. The roof is covered with a very clear wash of an almost transparent violet.

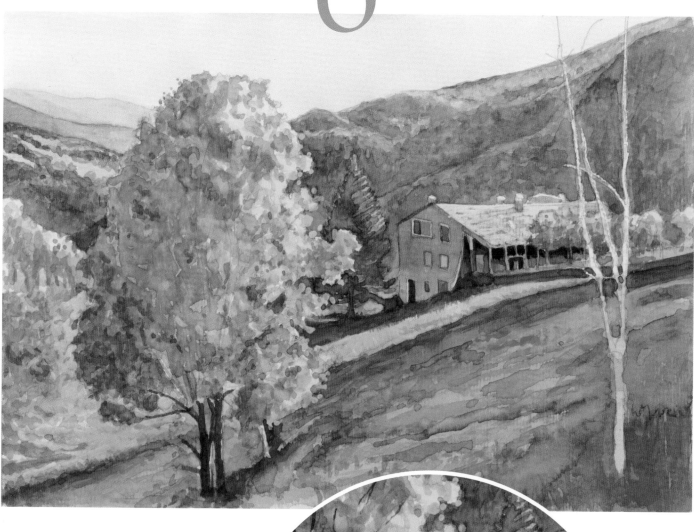

Details and texture

The details in texture are created using fine brush strokes on a watercolor that accurately represent the basic colors of the scene. The goal is to represent the twinkling changes of light reflected in the foliage of trees and blades of grass in the field.

STEP 6

Texture is achieved through the grouping of tiny almost dot-like spots on the foliage of the nearby tree, combined with watery spots and linear touches on the grass.

STEP 7

To achieve even greater definition, an intense-brown pencil is used when the paper is dry to clearly define the branches of the tree. Special attention is paid to branches that are thin and broken.

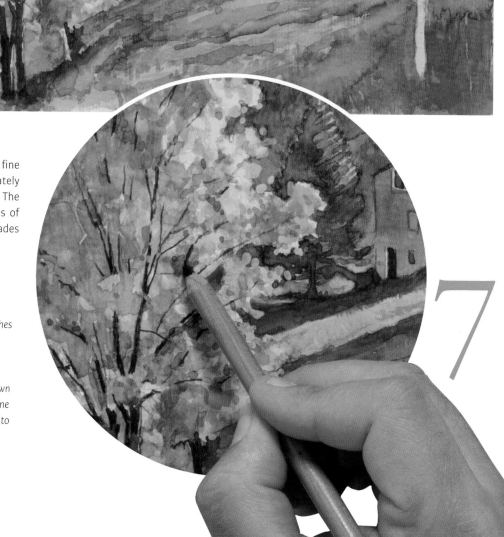

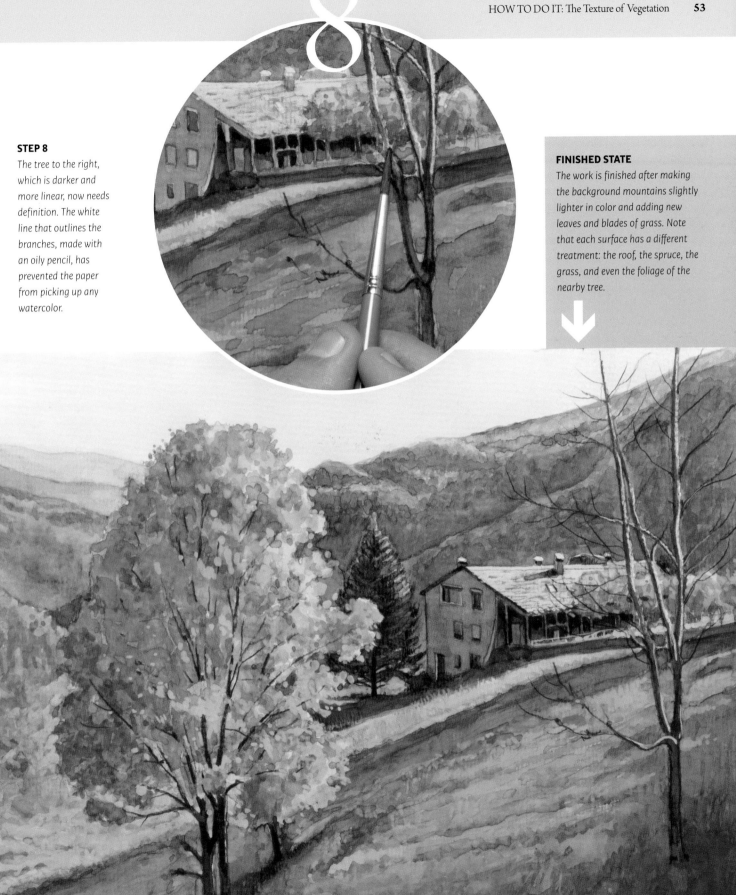

STEP 8

The tree to the right, which is darker and more linear, now needs definition. The white line that outlines the branches, made with an oily pencil, has prevented the paper from picking up any watercolor.

FINISHED STATE

The work is finished after making the background mountains slightly lighter in color and adding new leaves and blades of grass. Note that each surface has a different treatment: the roof, the spruce, the grass, and even the foliage of the nearby tree.

AN ARCHITECTURAL CORNER

The urban landscape is a complex genre highly respected among figurative artists. It is a humanized and artificial landscape in which architecture is very present, either intuitively or with a drawing that approaches an almost mathematical rigor. The following exercise is of a simple scene rendered in freehand perspective. We intend to demonstrate that such intuitive painting, the antithesis of methods practiced in many academic schools and also of perspective projection, is capable of offering very good results. This exercise, painted in a mixture of acrylic and oil, was developed by Mohamed L'Ghacham.

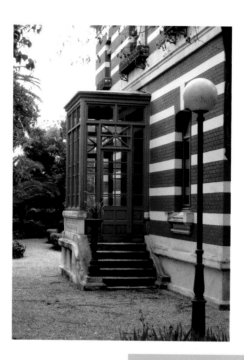

First phase with acrylics

To start the process of building a color base, acrylic paint is often used. Finishing touches and highlights are then added with oil. Artists who participate in fast-painting contests work this way. The acrylic allows for the applying of dilute, immediate, and fast drying stains, which will then be finished with the creamy and forceful character of oil paint.

SUBJECT

The subject here is an urban corner, an old entranceway to a garden. The perspective lines are not complicated, and the foreground street lamp brings some depth to the scene.

STEP 1

The drawing is done directly with orange-red acrylic paint diluted in water. It is a matter of first constructing the structure of the entranceway, the steps, the facade, and the placement of the street lamp.

STEP 2

With a thick soft-haired brush loaded with the orange-red used to make the drawing, a soft tonal shading is applied, then reinforced with new stains of very watery ivory black.

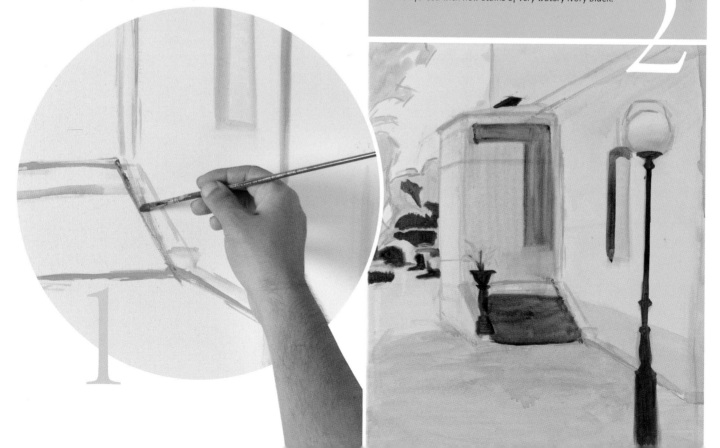

STEP 3

The first monochrome step evolves into color. The background and sky is worked out with blue lightened with white, as to appear almost gray; and variants of green are used for vegetation. The painting is thick and the interpretation loosely sketched.

STEP 4

The facade of the building is stained with a mixture of carmine and red. The bulb of the street lamp is given volume with a gradation of gray to white. Note the looseness of the brush strokes.

STEP 5

A new layer of carmine mixed with burnt sienna and lightened gray strips give greater strength to the facade. A moderately dilute application of olive green completely covers the entranceway.

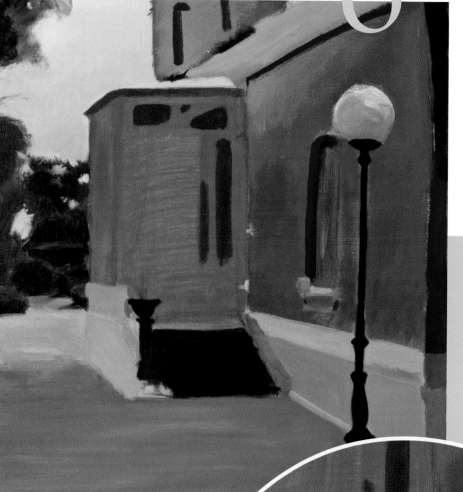

Large masses of color

As the work progresses acrylic stains are thickened, giving a more solid appearance. Details are left alone and the architecture is built with large blocks of color underscoring the main chromatic differences that define the planes of the house.

STEP 6

Little by little, windows are suggested. The staircase planter and street lamp are given increased definition by adding an intense gray. It is best to first build the overall shape or form, and then go on to add details.

STEP 7

Some vegetation greens in the background are shaded. This should be sketched and deliberately unfocused. Grass is added at the base of the lamppost. Taking advantage of the green tones, the entranceway is worked on again.

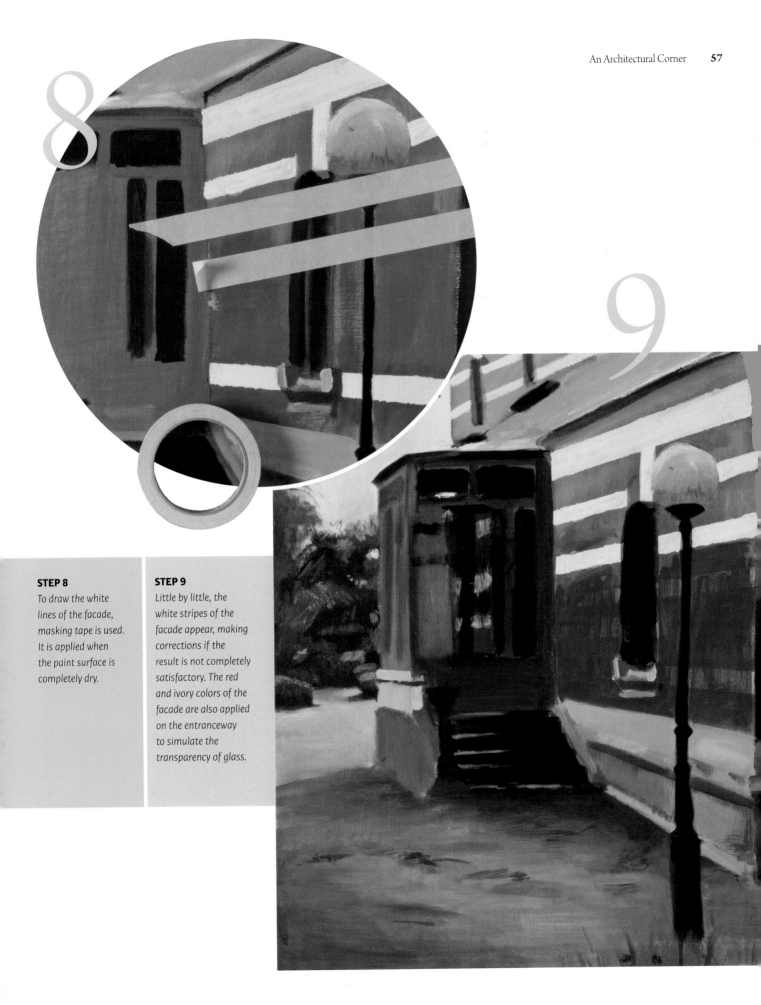

STEP 8

To draw the white lines of the facade, masking tape is used. It is applied when the paint surface is completely dry.

STEP 9

Little by little, the white stripes of the facade appear, making corrections if the result is not completely satisfactory. The red and ivory colors of the facade are also applied on the entranceway to simulate the transparency of glass.

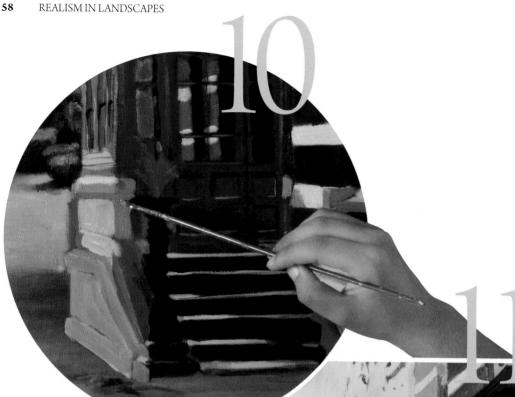

FINISHED STATE *A lightened carmine is applied to the facade and the stairs are darkened. The effect of moss is added, the lamp is lightened and the potted plant is painted. The last details are added. For all this, gray tones are used that connote a cloudy day. See some of the process in video 2.*

Corrections and oil details

The artist has introduced important format corrections and lengthened the entranceway and staircase. Once the architectural structure is created with acrylic, the goal is to enhance color, increase contrasts, and add details that require the greater opacity of oil. Since oil is a creamy medium it is very manageable and does not change after drying. These qualities allow for much better control over the final result. See video 1.

STEP 10

With a fine brush, the roof and the frames of the entranceway windows are worked on and the steps of the staircase detailed. The shadow of the entranceway interior is darkened with a very deep black.

STEP 11

Note the format of the painting. During this last phase, the artist has trimmed the right side of the canvas by a slight amount, which tightens up and focuses the composition on the entranceway.

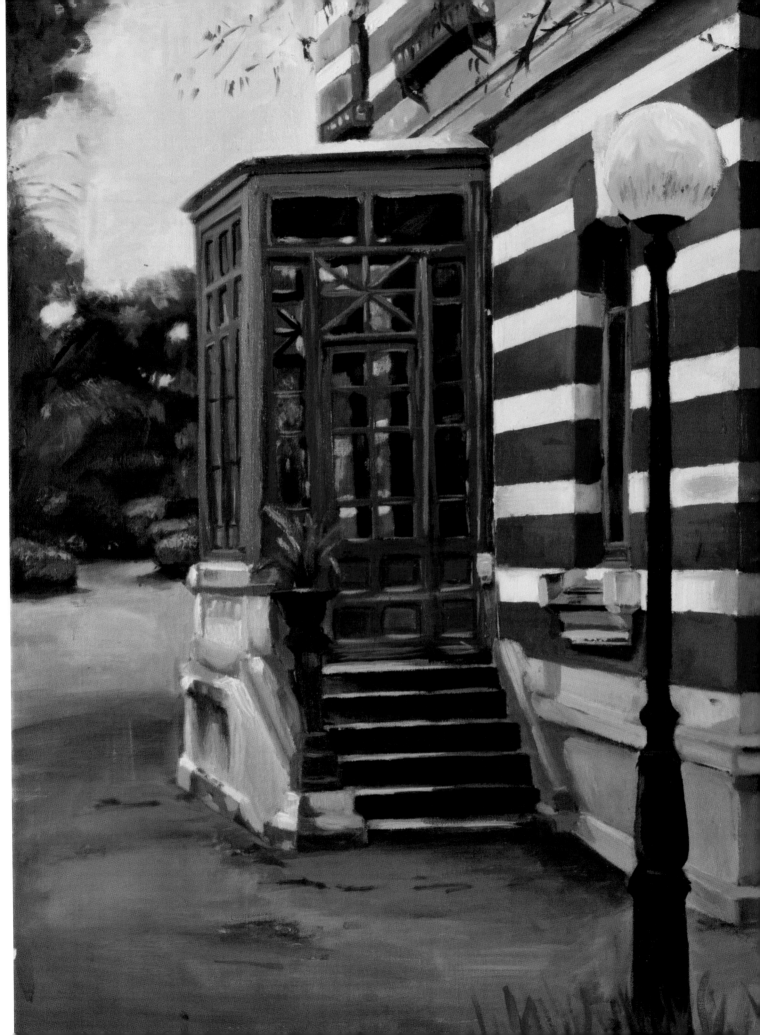

GALLERY:

URBAN SCENES

In contemporary realism, urban landscapes are a substantial part of the artistic scene. Photography is often the starting point for many compositions, but in no case does the realistic painter aspire to compete with the photograph and has, instead, a completely different motivation. Realism is not just the verbatim copy of a photograph or subject. Many artists offer interpretive variations that give character and a unique style to their work. Their aim is to reproduce reality, but as a new graphic reality of their own creation.

1 Joan Longas, *As the Parting Day Kneels.* Oil on canvas.

Often, architecture itself becomes the main protagonist of the work. The buildings here are large volumetric structures that have an intrinsic beauty and generate interesting sets of lights, shadows, and reflections. The contrasts between old and new and the frames cropped by the influence of photography become stimulating motifs that pleasantly surprise the viewer.

2 Daniel Cuervo, *Sunset in Barcelona from Miramar.* Oil on board.

Photorealistic artists paint urban scenes with great dexterity and technical ability using photography as the basis for the development of their work. These motifs are first captured through photography and then transferred to the canvas by a painstaking drawing process. These are works painted with such precision and accuracy that the canvases themselves produce the impression of photographic quality.

1

2

3 **Joan Longas, *A Low Swung Foreign Speedster with No Top Drifted into the Parking Lot*. Oil on canvas.**

The urban corner of an antiseptic city lacking textures, cracks, or imperfections. Flat paint turns every object into one showing no evidence of the passage of time: everything seems new, shiny, and unused. The main interest of this painting lies in the reflections of light on the metallic surface of the vehicle, the interior lights of the shop, and neon lights. Cars are especially significant icons of realism. They signify mobility and freedom and, therefore, are a very representative part of contemporary society.

4 **Gabriel Martín, *A Bike Ride*. Watercolor.**

Watercolor offers a range of possibility, from creating a very elaborate painting with endless architectural detail to one that is more simplified, such as seen in this clean and sunny facade. This is a scene bathed by an intense sunlight, suggested by the white highlights on the back of the cyclist and by the shadow projected onto the ground. The inclusion of figures in an urban setting is very useful for the viewer to have a reference point with which to compare the proportions of the surrounding buildings.

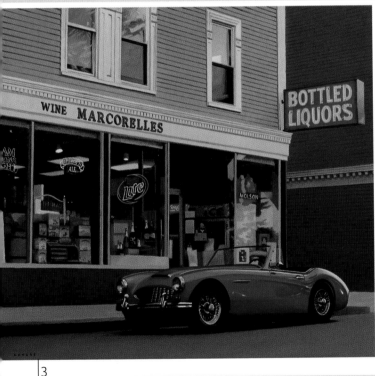

3

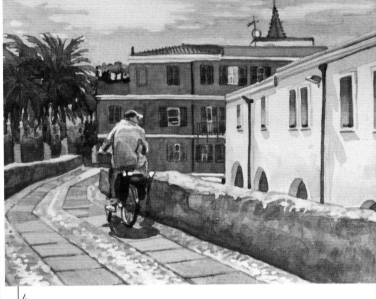

4

IN DETAIL: NIGHT SCENE WITH FIGURES

The realistic painter often portrays moments of reality frozen in time, urban scenes where the human being appears immobile, captured in full action, as if it were a photographic snapshot. This is often the case with scenes in the big city where passers-by blend with shop lights, fast-food restaurants, static advertising, traffic lights and canopies, and shop windows with banal objects of consumption. Busy nightlife is a theme that conveys the dynamism of today's society, in its attractive play of lights, projected shadows, and reflections.

1. *The realistic artist walks the streets of the big city holding a camera, trying to freeze time and capture those scenes where people and traffic interact with the urban landscape.*

|1

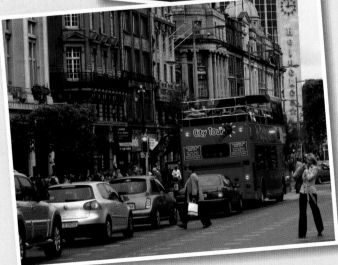

2.1. *The glass screen at the bus stop is not completely transparent and offers violet colorations. There are overlapping brush strokes of grayish tones that render light reflections on its reflective surface.*

2.1|

2.2. *The shadows cast an interesting set of shapes, shades and dimly lit areas caused by the incidence of various light sources upon the figures, some of which present a ghostly and disconcerting appearance.*

2.3. *The effect of neon light here is achieved by painting the zones of progressive luminosity by value range, adding the most intense lights at the end and surrounding each panel of light with a dark frame. Note that some letters even have a blended contour that suggests the spread of light..*

2.2|

2.3|

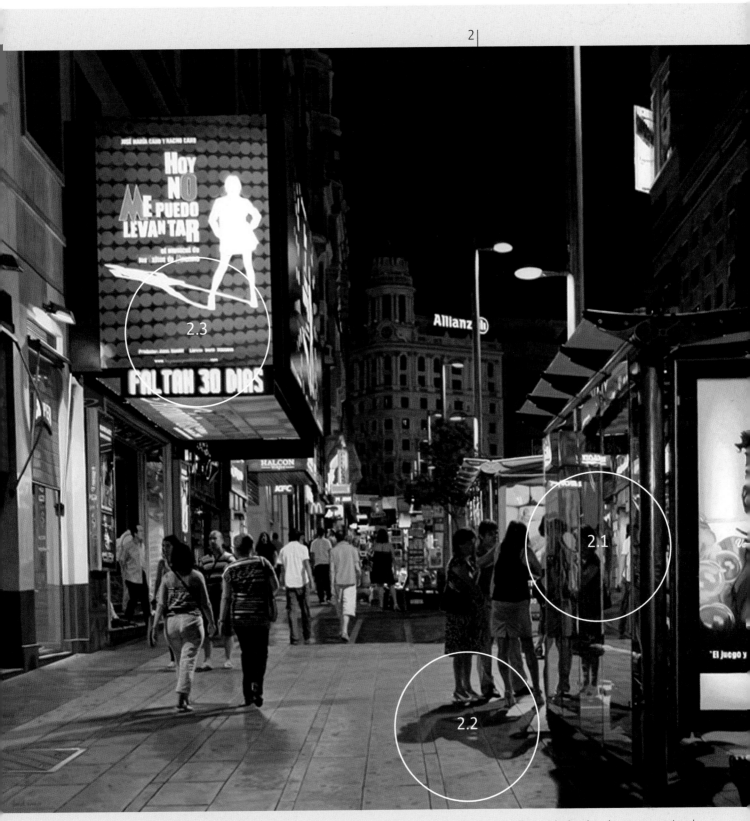

2. *Daniel Cuervo. Today I Cannot Get Up. Oil on canvas. An urban night landscape has a different color key than the same scene viewed during the day. This is because many light sources intersect at the same time, casting blue, violet, yellow, and orange shadows and reflections that enliven and enrich the final painting.*

HOW TO DO IT:

GEOMETRIC SHAPES IN WATERCOLOR

In contemporary cities, the geometry of contrasts and abrupt changes in light intensity prevails. If we add a skyscraper, the result is a complete urban landscape exercise. Painting by Gabriel Martín.

Notions of perspective

When painting skyscrapers it is important to consider basic notions of perspective, based on the projection of converging lines that direct buildings towards an imaginary point in space. This form of projection can be applied, above all, to the representation of facades as seen from their base. The angling of the lines creates the feeling of height and elevation.

SUBJECT
Using some basic principles of perspective, the skyscrapers are delineated by synthesizing their shapes into simple geometric forms.

STEP 1
The drawing requires a ruler used to project the converging lines that define the architectureThe drawing structure of the buildings must be properly constructed.

STEP 2
We begin by applying watercolor to the sky. First, the sky area is moistened with a brush soaked in water. We apply cerulean blue and cobalt blue, letting them blend on the paper and leaving the area of white clouds unpainted.

STEP 3

With a fine round brush, geometric shapes that define the frames and windows in the facade of the building begin to be constructed. The diagonal arrangement of these colored bands is based on perspective.

STEP 4

The first washes are soft. They aim to sketch the windows of the buildings and offer the opportunity of building the architecture by assembling four-sided colored sections.

STEP 5

The areas that receive direct sunlight are left white—the color of the paper—while the shaded areas begin to be covered with soft bluish, burnt umber, or violet washes. The contrasts are still soft and unpronounced.

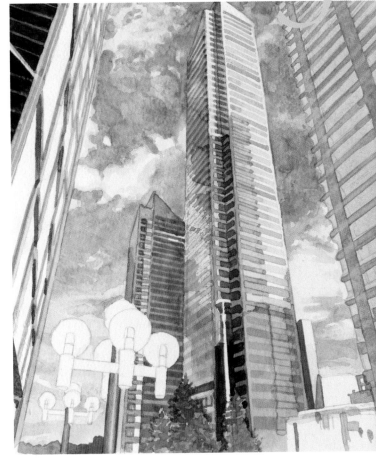

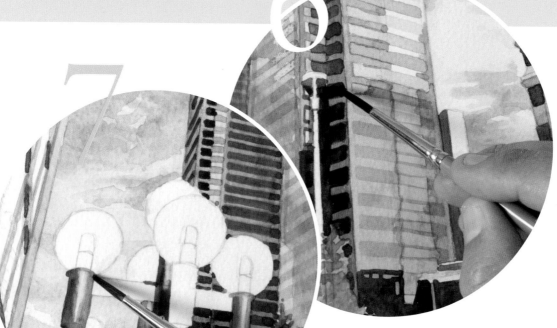

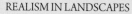

STEP 9

The glass lampposts are made with a gray-violet wash while preserving the white of the highlights. The contour of the glass bulb features a slightly darker gray line.

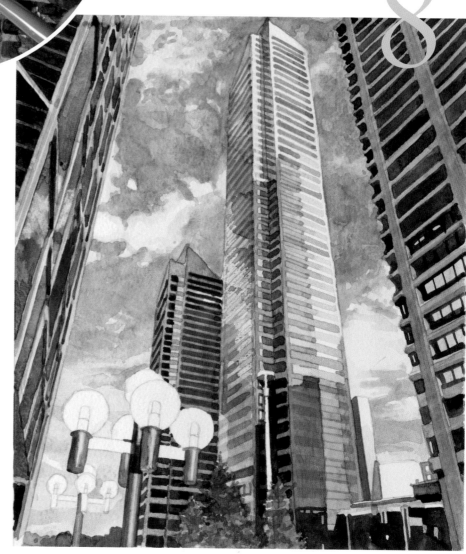

Painting more pronounced contrasts

The deepest shadows and the sharpest contrasts are now painted on a watercolor base of soft and luminous colors. Without the opposing contrast of light and shadow it would be very difficult to represent architectural volume. The buildings would lack depth and appear flat.

STEP 6

With a saturated Payne's gray, the spaces of the building's windows on the right are painted and the same color is used to contrast the shadows at the base of the tallest skyscraper. These color bands representing windows should maintain perspective.

STEP 7

The middle-ground building windows are darkened. On the sockets of the street lamps a gradation of Payne's gray is carefully applied, leaving a thin strip of white at the midpoint to represent metallic reflection.

STEP 8

To paint the reflections of glass of the building on the left, a mixture of indigo, cobalt blue, and a little gray is used. With the wash still wet, the white reflection of the clouds is rendered by pressing and blotting with absorbent paper.

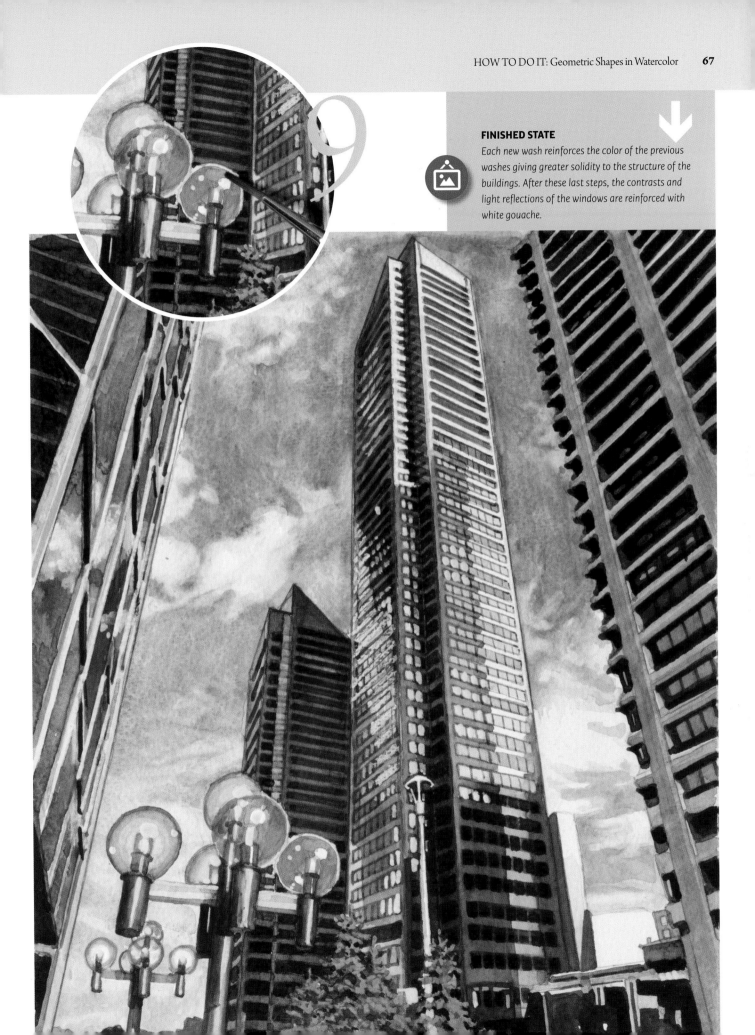

FINISHED STATE

Each new wash reinforces the color of the previous washes giving greater solidity to the structure of the buildings. After these last steps, the contrasts and light reflections of the windows are reinforced with white gouache.

URBAN LANDSCAPE WITH FIGURES

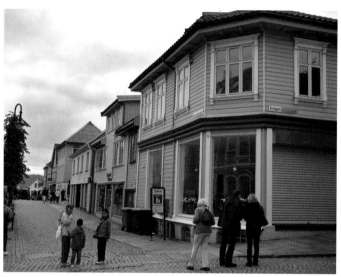

SUBJECT
This scene poses problems of perspective, with the added difficulty of depicting a group of figures that interact within the urban scene. There are also other factors involved: reflections on a shop window and texture on the ground.

Preparing the palette

Before starting to paint, it is advisable to carefully study the chromatic configuration of the subject while noting basic colors, and then decide which paints will be added to the palette. These are the colors chosen by the artist for this exercise: ivory black, cobalt blue, cyan blue, titanium white, cadmium yellow, yellow ocher, English red, cadmium red, madder carmine, transparent red iron oxide, and raw umber.

The urban landscape involves many challenges of perspective, especially when painting a street scene that includes figures and extends into the background with the progressive decrease in facade sizes. Here, the greatest difficulty lies in making a good drawing, carefully selecting elements that will appear in the picture, and recreating the reflections of light on the glass of the foreground house.

For the work to convey the feeling of reality it isn't necessary to strictly follow the colors of the subject. Here, the colors were altered to achieve a representation with more cheerful and warmer tones. The painter Adrià Llarch created this exercise in oil.

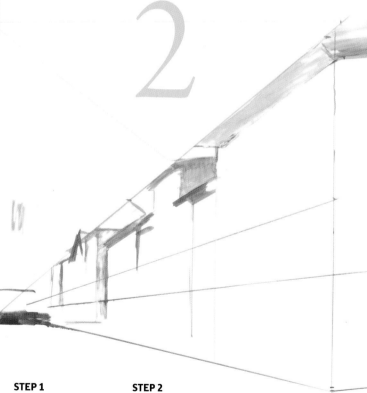

STEP 1
The first step is to project the perspective of the buildings, drawing the vanishing lines with the help of a straightedge. This is done directly on the canvas with a fine brush loaded with raw umber diluted in turpentine.

STEP 2
The preliminary drawing should not be too meticulous, but it should pick up the height of the roofs, the base of the houses, and some guidelines for window height..

STEP 3

With a soft-hair brush, some tonal spots are added to the perspective lines. The most intense shadows appear very diluted and reinforce the structure of the drawing.

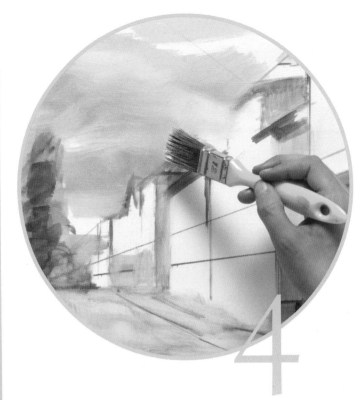

STEP 4

With a flat brush, the sky is painted using a mixture of whitened blue and pink. The artist should intend to give a little more chromatic richness to the gray sky of the real subject by introducing pastel tones.

STEP 5

Some yellowish colorations are added to the pastel bluish and pink tones. Without losing luminosity, these blend gently to recreate the effect of the clouds covering the sky.

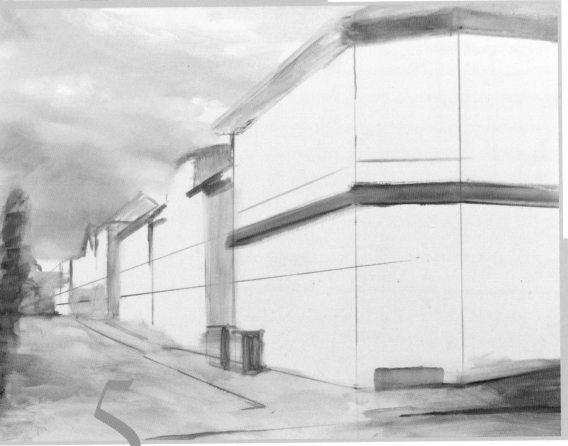

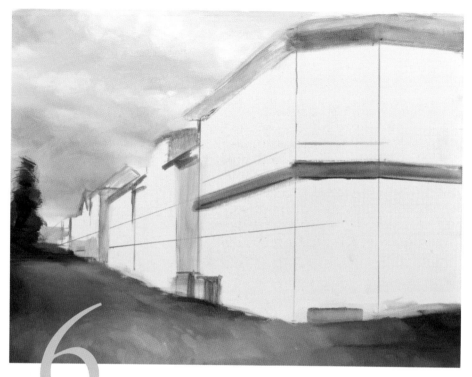

Beginning with the background

When a painting has depth, it is always advisable to start by working out the background. The far facades are synthesized with spots of mostly uniform color and with little detail, due to the blur caused by distance. No matter how realistic the work may be, it would be a mistake to over-detail more distant areas.

STEP 7

The facades of the houses at the end of the street are painted with flat surfaces and only a couple of values. The paint is opaque, oily, and somewhat whitened. There is no trace of windows or doors.

STEP 8

The treatment of the middle-ground facades is similar to those in the background. These are covered with a layer of compact color with slightly more saturated tones. The eaves of the roofs and the shade they cast are indicated with stronger and more precise lines.

STEP 6

With the same flat brush, the base color of the street is applied, blending different shades of gray with raw umber, cobalt blue, and some ocher. Here the paint is a little less diluted than in the sky.

STEP 9

As the artist moves toward the foreground, a thicker brush is used. The difference in values of the facades that define the corner of the building is represented by mixing ocher, white, cadmium yellow, and red iron oxide.

STEP 10

When the paint of the facades is very dry, the doors and windows are rendered. With a fine brush, simple holes are painted in the background. In the middle ground, they are more detailed with colored frames. Watch the video to see how this is done.

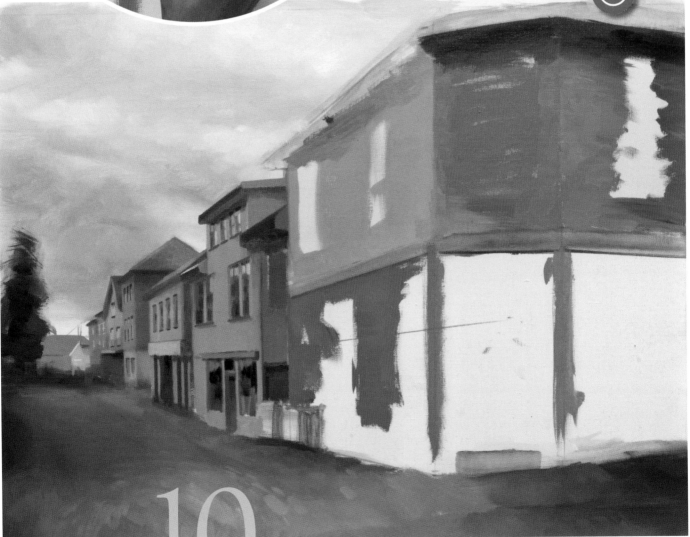

Palette used by the artist in the last phase of the painting. Its warmer colors allow a better definition of the foreground.

Change of palette

After several days of work, the artist modifies the color palette that was used initially. The palette now consists of ivory black, cobalt blue, cyan blue, titanium white, cadmium yellow, yellow ocher, cadmium orange, cadmium red, madder carmine, burnt sienna, and raw umber. This new palette allows for rendering the warm and lively colors of the foreground with greater saturation and luminosity than in the real subject.

STEP 12

With sketched stains of whitened gray the reflections of the windows are defined, showing a distorted image of the opposite building. The facade walls are finished by applying color in a flat manner with a mixture of ocher, yellow, and turquoise blue.

STEP 13

In this last phase, the figures are rendered with a fine brush. The contrast between light and shadow is fundamental for defining the faces and texture of clothing, as can be seen in the video.

STEP 11

The columns are painted with blocks of color, giving them the appearance of solidity and volume. The window frames are overlaid with whitened grays. The straight line of the building eaves is achieved by preserving this area with paper tape.

FINISHED STATE *It is important to capture the pose of the figures and give them solidity using vivid colors that contrast with the background. Finally, a few touches are added to give texture to the paved street.*

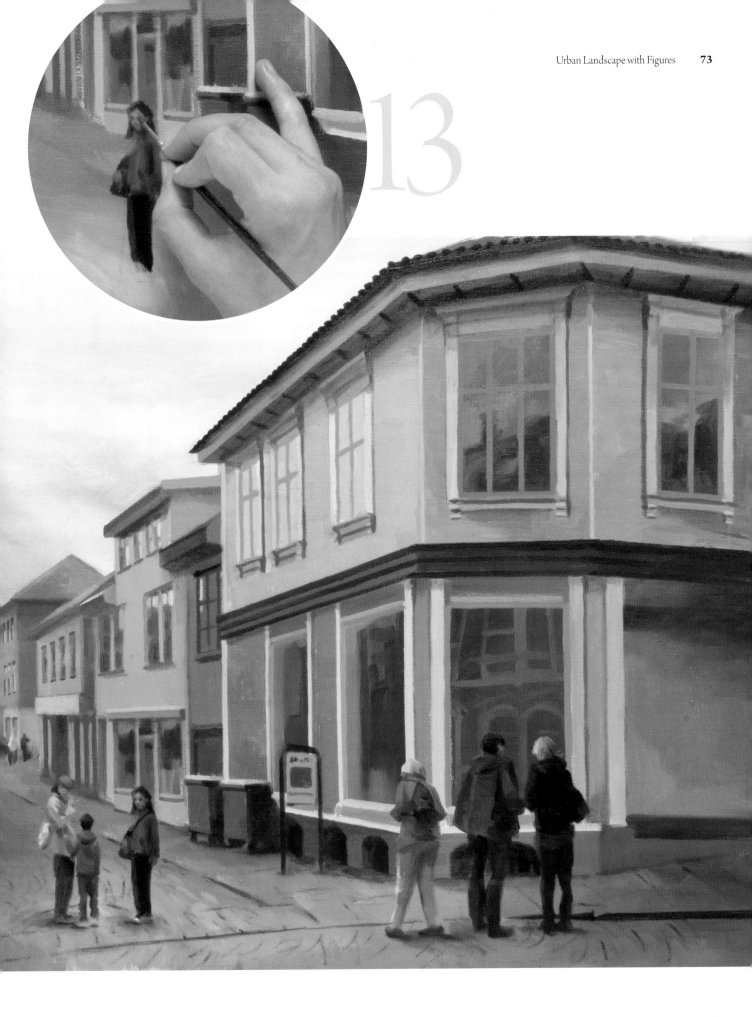

IN DETAIL: TEXTURE OF A STONE WALL

When approaching a wall or facade, the surface and tactile quality of the materials with which it has been constructed are discovered. When working with watercolor, there are techniques of color application that are useful for rendering rough and textured surfaces. The best way to suggest grainy and rough textures is to load the paintbrush with lightly diluted paint and apply it onto the paper using light touches to form small dots or units of color. Next we analyze how Gabriel Martín Roig has painted a fragment of wall composed of very rough and porous stones.

1. *The grainy texture is achieved by hitting the surface with a brush loaded with not overly diluted paint.*

2. *The objective is to recreate the visual impression of a set of rough-textured stone blocks. To do this, the result should be convincing and fully rely on how color is applied with the brush.*

2.1. *The effect of light on stone is conveyed with a gradation that goes from bluish gray to slightly darker violet gray.*

2.2. *The cracks must be decisive. The slit is covered with a deep black and small spaces are left uncovered to simulate loose fragments of stone inside the crack.*

2.3. *The light shadows of a transparent gray contribute to the description of the stone blocks' surface relief. To describe the slight irregularities of the stone the contrast must be soft.*

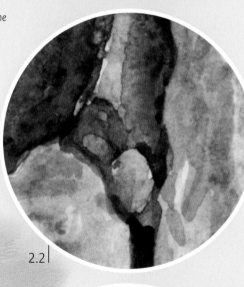

2.1

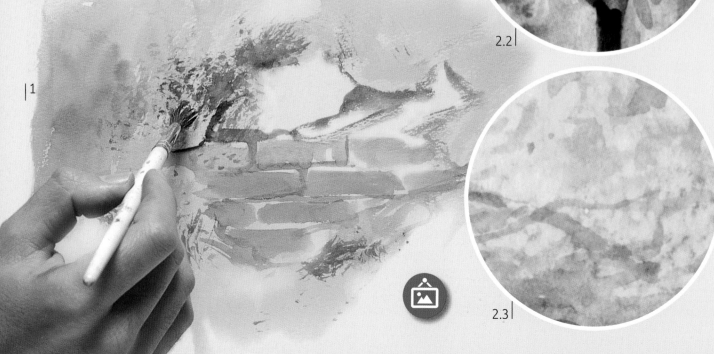

1

2.2

2.3

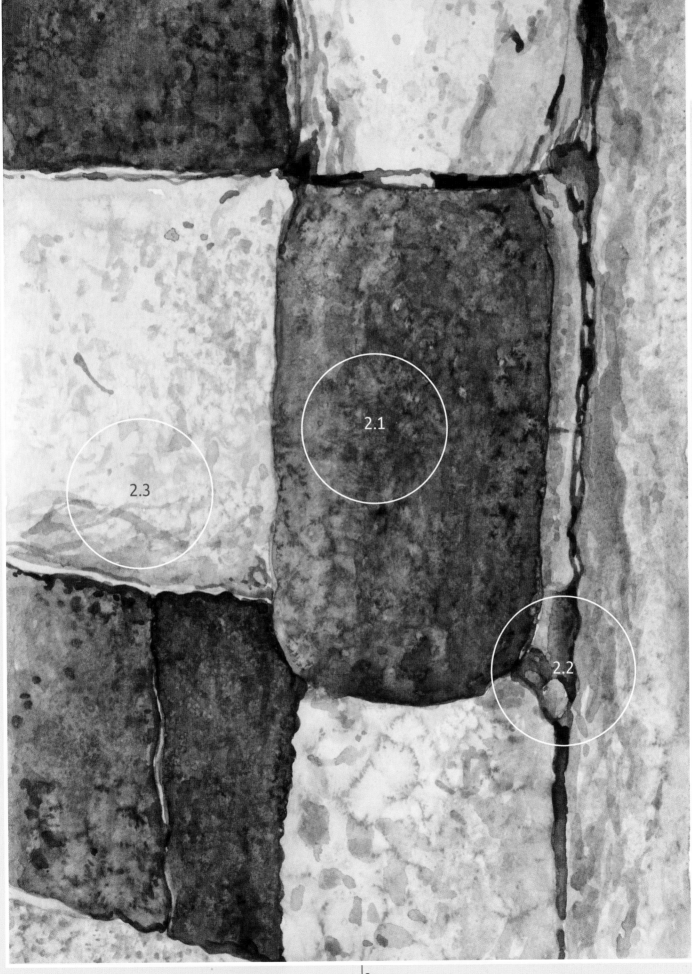

GALLERY:

VEHICLES

When attempting to represent the wide variety of vehicles traveling through a city, burnished metals, metallic paints, and distorted images reflected in shiny surfaces are the main challenges facing realistic painters. The metallic and polished surfaces of urban vehicles reflect light and become interesting subject material where artists can demonstrate both their technical knowledge and ingenuity in capturing such effects. Most surfaces are curved or convex, unevenly concentrating highlights, offering both shadows and highlights of high intensity and surprising shapes.

1 Mohamed L'Ghacham, *Parking.* **Oil on wood.**

The painting portrays the atmosphere of a local workshop. The intense gradations and reflected light define the shape of the cars that appear deep in shadow. Two photographic resources have been used. One focuses on the center of the scene rendered with blasts of light and precise forms, and the other blurs the surrounding area, which is worked using more diluted paint and sketched elements. The transparency of some color applications and trace of drips give the work a freshness and immediate quality.

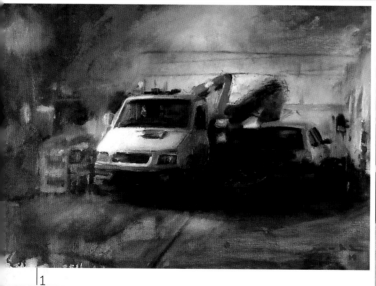

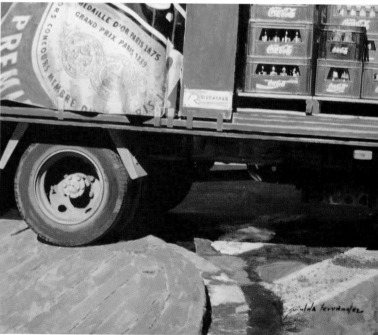

2 Griselda Ferrández, *Truck.* Mixed technique on canvas.

The framing is fundamental to focusing the viewer's gaze on the anecdotal. We must learn to identify the plasticity and the beauty of everyday life, which, in this case, is a vehicle loaded with soda. The contrast between a blinding light and cast shadows provides the definitive interest to the protagonist of the scene, a wheel. Small details such as the highlights of the soda bottles or the wear of the tire contribute a degree of truthfulness to the painting.

3 Griselda Ferrández, *Yellow Train.* Oil on canvas.

The railway has regained an interest among contemporary realist painters, a subject that has not enjoyed favor since Impressionists created the magical atmosphere of steam engines arriving at a train station. The portrait of a vehicle, rendered with an intense yellow, is imposing and conceals neither dirt nor the effects of passing time. Again, the cast shadows add interest and break the uniformity of color.

4 Griselda Ferrández, *Taxi in London.* Oil on canvas.

With its interesting and exciting reflections and highlights, the automobile is a recurring theme among lovers of the big city. As a shiny and attractive cult object, the automobile's curved forms distort light to such an extent that the highlights become stylized, white stains of strong visual impact. Light reflections often have a sketchy appearance and are made with several whitened and blended colors. The final impression comes from the strong contrast of deep blacks surrounding each highlight.

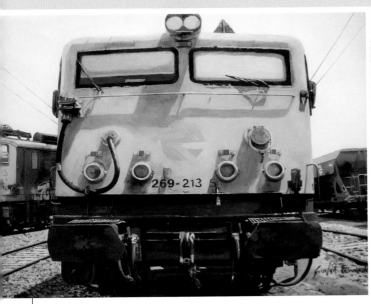

3

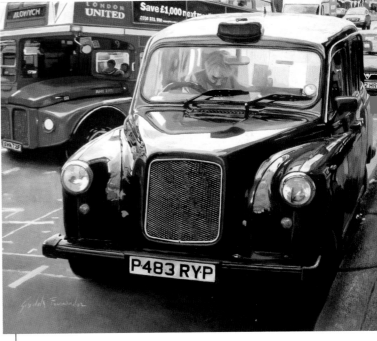

4

A BRIDGE IN WATERCOLOR

To avoid falling into any error of representation, the next work is long and meticulous and will take into consideration both perspective and the careful construction of the drawing. The most complicated element is not the many details presented by successive facades, but the rendering of tone and contrast between light and shadow, which convey the illusion of volume together with the reflections that appear on the calm surface of the water. This step-by-step process is executed by Gabriel Martin Roig, using the watercolor technique.

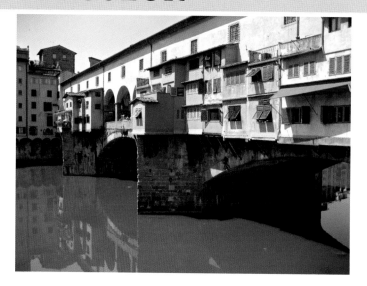

SUBJECT
The scene combines architecture and perspective with interesting light effects caused by the reflections on the water and intense shadows under the bridge.

Perspective drawing

In order to work confidently on this, it is advisable to devote considerable time to constructing a solid foundation in the preparatory drawing. To do otherwise would make the coloring phase difficult. A metal ruler is used to make the first and longest perspective lines and then the drawing is completed freehand, using a 2B pencil. This pencil is recommended as the most suitable so the lines will still be visible after the application of the first washes.

STEP 1
The bridge structure is rendered first, based on the diagonal lines defining its perspective. The architectural elements are treated as if they were uniform geometric blocks. The bridge arches are more of a challenge to draw. First, the space is delimited with perpendicular lines and the arcs then drawn with tangent curves.

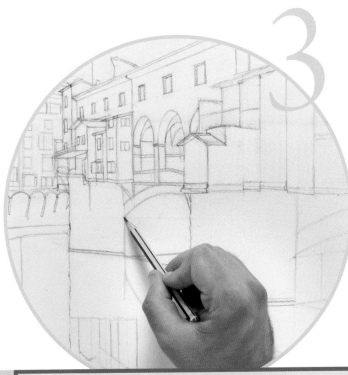

STEP 2

Upon the structure of the bridge, the other three-dimensional elements are constructed. It is a matter of defining the small buildings facades attached to the bridge as if they were rectangular superimposed blocks.

STEP 3

On the main construction lines, the houses that rest on the bridge are fitted, defining their angles, arches, roofs and arrangement of windows. All this should be done freehand.

STEP 4

After several hours of work, the drawing of the bridge is ready for painting. The lines are too intense, but that should not be worrisome. The important thing here is to make sure that the drawing is satisfactory.

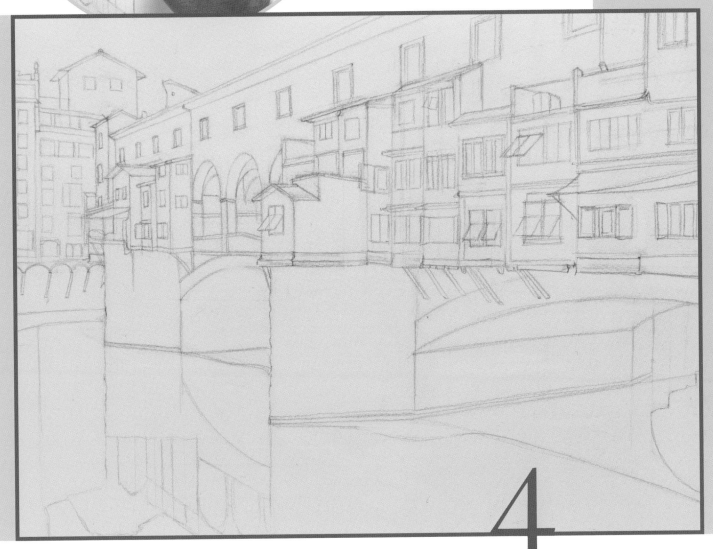

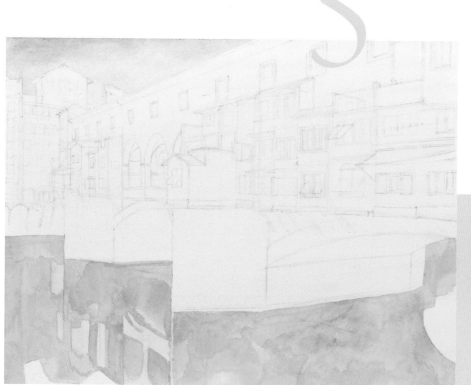

Applying washes technique

Applying watercolor is done with the traditional method of adding washes, which consists of intensifying color progressively, applying one layer over another. This working method permits progress in a controlled fashion and offers a smaller margin of error than if direct color mixes and more saturated paint are used.

STEP 5

Before beginning to paint, the drawn lines are gently softened with an eraser. Then, with a thick round brush, the water area is colored with very dilute raw umber, and the sky with cyan blue.

STEP 6

With a fine brush, the shaded areas of the facades are worked on using washes of color that blend into the bridge pillars: Payne's gray, raw sienna, and burnt umber.

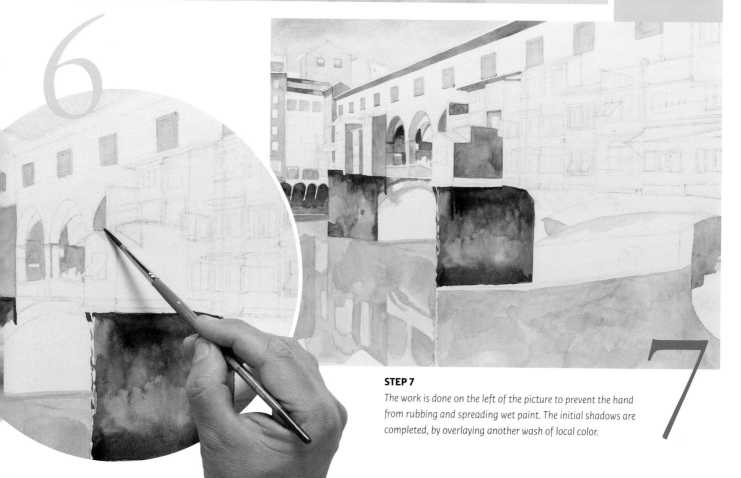

STEP 7

The work is done on the left of the picture to prevent the hand from rubbing and spreading wet paint. The initial shadows are completed, by overlaying another wash of local color.

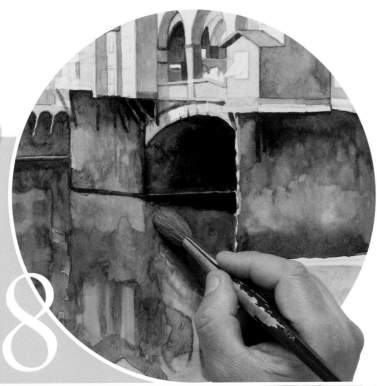

STEP 8

As the facades are covered with new layers of transparent color, the area of the water is painted with an olive green. The shadow of the arch of the bridge is completed with very saturated Payne's gray. The process is simple as can be seen in the video.

STEP 9

With watercolor, it's necessary to be organized and work on different areas at the same time while allowing the most recently painted areas sufficient time to dry. This is why architectural elements like the facades are worked on concurrently with the painting of the water.

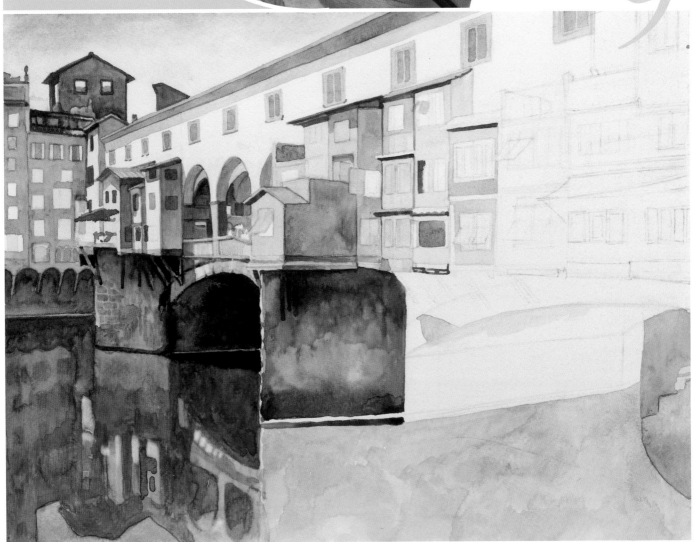

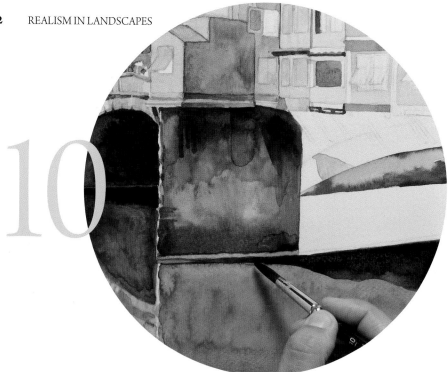

10

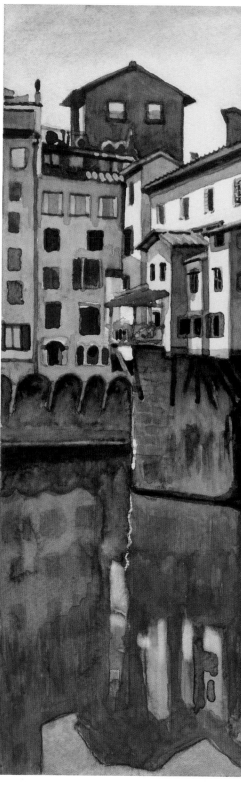

The home stretch

The darker shadows underneath the bridge are painted with a mixture of Payne's gray, ocher, and burnt umber applied using the wet-on-wet technique. The colors form gradations by being allowed to blend. Once the arches and facades have been rendered, it is time to address all the architectural details of each building: downspouts, windows, shutters, grilles, and balconies. A fine round brush and a sharp black pencil are used.

STEP 10

On the surface of the water you must respect the reflections and the edge of the dark shadows. The appropriate green tone is achieved by overlaying new washes on the previous ones. As the tone intensifies the light reflections are more evident.

STEP 11

The main areas of color are now almost finished. The color of the base gradually intensifies to represent the effect of light on the building facades. Without shadow, there is no light.

11

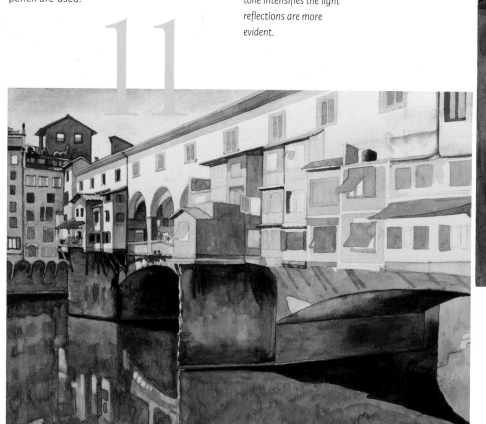

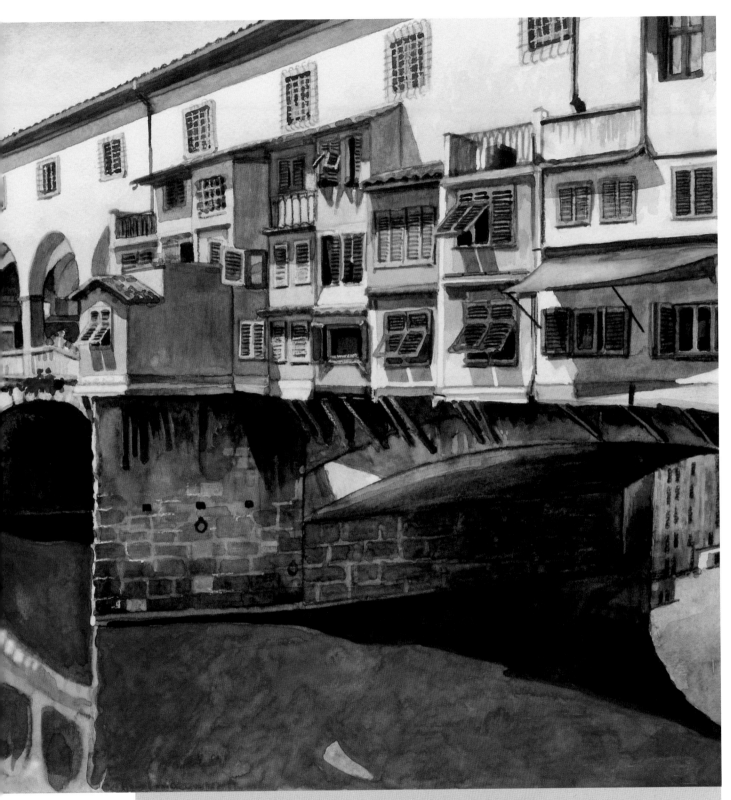

FINISHED STATE *The painting is finished using a touch of white gouache for detailing bridge texture, including the wooden beams and stone blocks. Detailed representations of facade openings are made using a fine brush, a watercolor black pencil, and a white oil pencil. Watch the video to see the procedure.*

HOW TO DO IT:

BACKLIGHT IN ACRYLIC

Windows are spaces that open to the world. The analogy of a window to a picture is obvious. However, a window itself constitutes an object of great visual interest that complements building architecture. A backlit window offers an opportunity to study a range of elements, from the values of the shadows to the manner in which light bursts into and expands throughout an interior room. A window represents an interesting play between a solid and contrasted interior space, and a diffused and whitened exterior. The following exercise demonstrates how everyday objects can be optimal models. Executed in acrylic by Gabriel Martín Roig.

SUBJECT

The subject is a backlit, old, half-open, wooden window. Through the glass you can infer architectural elements suffused by intense light.

STEP 1

The window frame, the shutter, and wall tiles are defined with a graphite pencil using linear strokes.

STEP 2

To work with acrylic washes, it is important—as will be seen during the initial steps of the exercise— to make a solid drawing to define the main areas of color.

STEP 3

A gray color is prepared to spread a first monochrome staining. The lighter areas are left blank while the shadows are defined with very water-diluted paint.

STEP 4

The shadows on both sides of the shutters are a mixture of Payne's Gray and violet. The shades of gray are bluer on the tiles.

STEP 5

The upper part of the window is darkened with the addition of violet and blue gradations. As the area around the window is shaded, the light coming through becomes more intense.

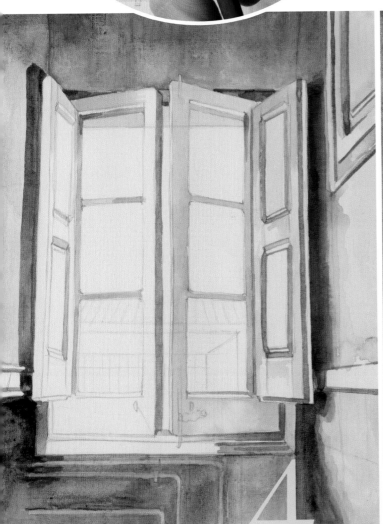

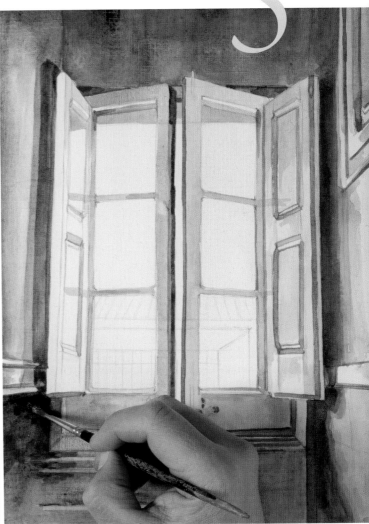

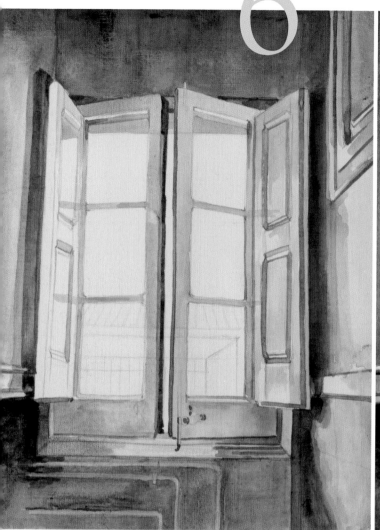

The effect of light

Once the main areas of shadow are applied it is time to more precisely define the light. To do this the contrast of shadows around the window is increased. The most important highlights are then defined with titanium white acrylic paint. The addition of burnt umber is fundamental to achieving the warmer chromatic environment of the scene.

STEP 6

The window frame is painted with very transparent washes, and absolute white remains only on the highlights. Carefully, and with a fine round brush, frame moldings are detailed and the pipes in the lower area are contrasted.

STEP 7

With a mixture of gray and burnt umber, the window frame is darkened by the effect of the backlighting. With this same brown wash, the tiles and the pipes are defined and projected shadows reinforced.

STEP 8

Finally, the sky is painted and the light areas of the shutters are reinforced with a dense titanium white, which is also used to whiten exterior architectural structures.

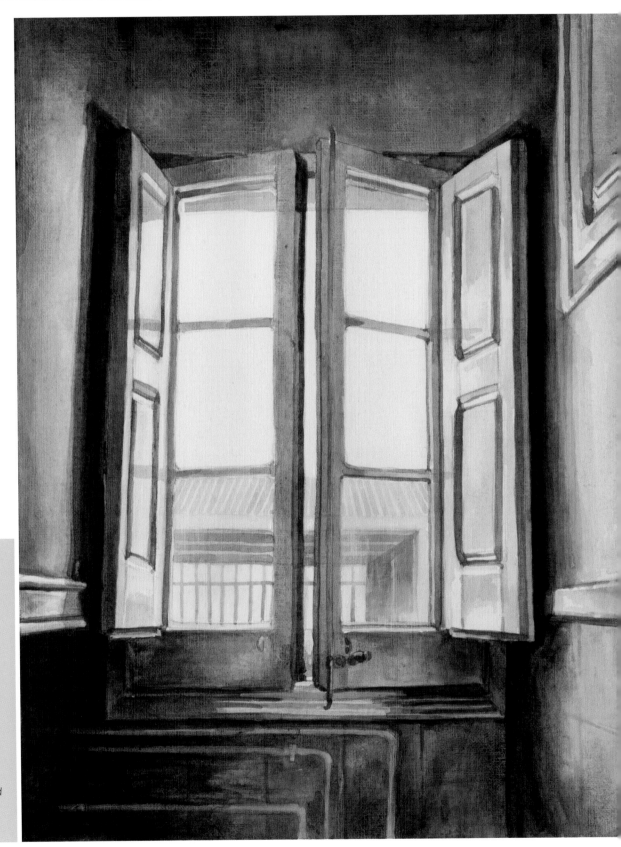

FINISHED STATE: *The success of a realistic painting is not based on correctly guessing the color but on portraying an adequate representation of atmospheric lighting. The realistic effect comes from many details such as the window handle, or wood moldings.*

IN DETAIL: A BICYCLE IN OIL

Within a city, there can be seen many different types of vehicles ideal to use as subject models. But there is one vehicle in particular that holds a special attraction: the bicycle. Isolated bicycles, those that are immobile, tied to a pole, to a lamppost, or a pylon, offer an opportunity to combine cycling, architecture, or landscape within the same theme. To find inspiration, you only need to walk around the city a bit to spot bicycles in hundreds of different places. It is enough to choose those whose structure is more stimulating or that are part of a more attractive background. On the next page, the work *Orange Bicycle* has been painted in oil by Griselda Ferrández.

1. The linear structure of the bicycle, its simplicity, shape, variety of textures, and reflected highlights, make it a very attractive subject for the realistic painter.

2.1

| 1

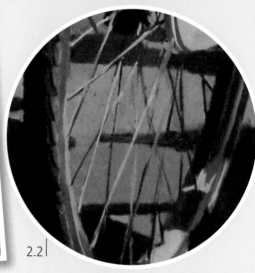

2.2

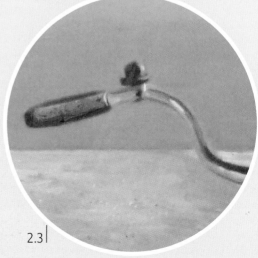

2.3

2. *The bicycle becomes the main protagonist of the story. Composed of interlaced rhythmic forms, the bicycle stands motionless before a solitary beach. Its shadow casts an interesting shape on the ground, enhancing its strong linear structure.*

2.1. *The texture of the wood is achieved by suggesting the grain with gray brush strokes. The orderly layout of the blacks, in perspective, and their strong contrast marking out each piece of wood do the rest.*

2.2. *When the painting is completely dry, a fine round brush is used to paint the wheel spokes using a ruler. It is best then to leave the painting of the spokes to the end.*

2.3. *The metallic handlebar highlights are long, juxtaposed brushstrokes of grays, blacks, and whites; distinct bands of color that hardly mix with each other.*

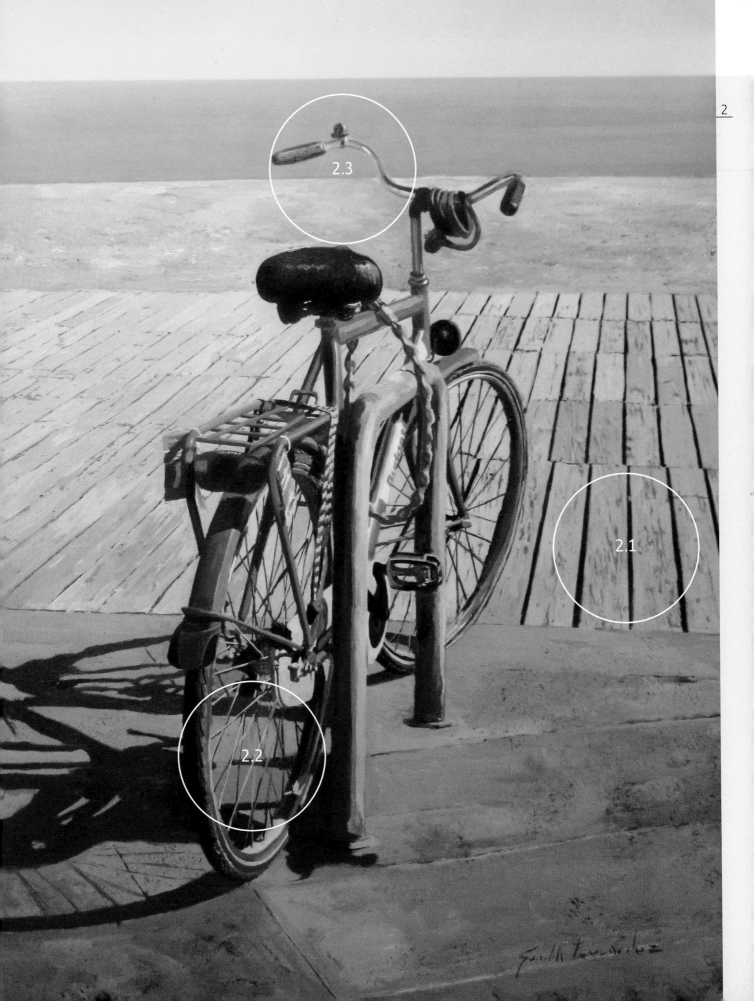

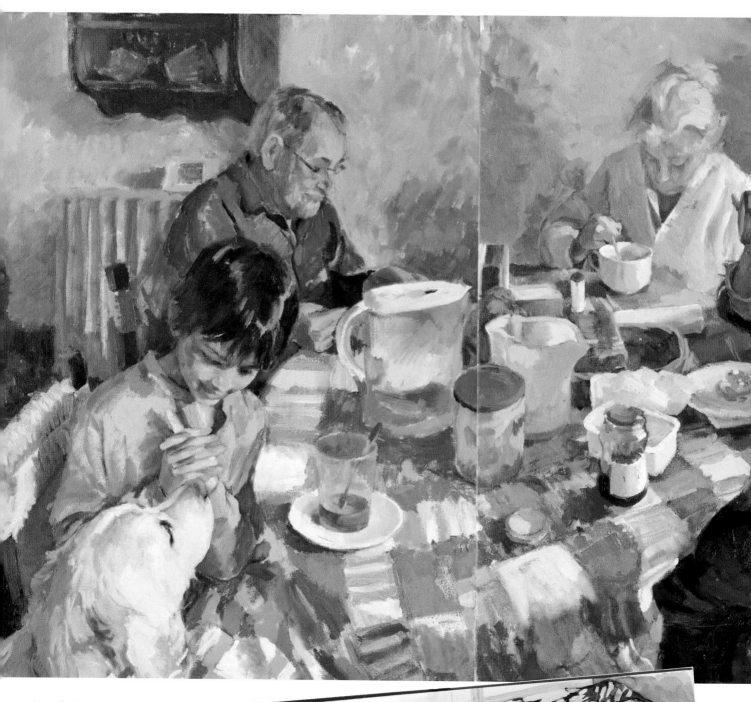

Mercedes Gaspar,
The Family Gathering.
Oil on canvas.

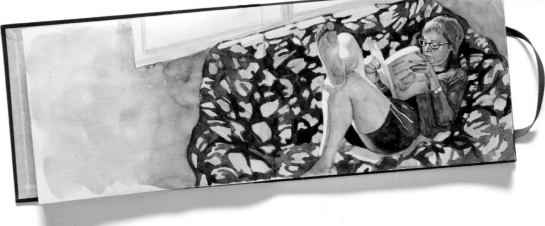

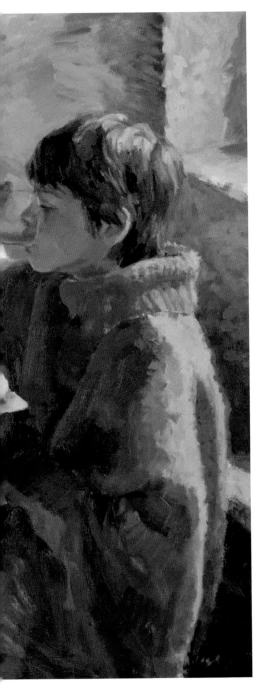

Realism in the human figure

The human figure, dressed or undressed, in an intimate or urban setting, is an essential subject for the contemporary realistic painter. It represents the culmination of academic learning—the last link in realistic representation—and is one of the genres that offers the amateur greater difficulty and a challenge. The opportunities to paint people are many: family members, models in a studio, passers-by, and even our own image reflected in a mirror. The figure requires more precise drawing than the genres treated earlier in this book because any defect is easily perceived by the viewer. In this section, we will offer some guidelines that will help improve your working method as well as formulas to control colors mixtures and successfully render modeling and painting of flesh tones and colors.

A KAYAKER IN OIL

Unless you are painting a figure posed in an art studio, where the lighting and background can be controlled, you will typically have to find your models from your immediate environment, choosing subjects from the people around you. These real-life "models" are usually not immobile, waiting to be portrayed, rather they interact with the surroundings and may be performing a specific activity. This work captures the moment when a kayaker is carried away by a river current. Oil painting by Christian Duran.

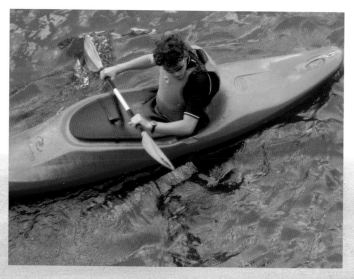

Drawing is the base

It cannot be stressed enough that the success of a painting depends on a well-executed drawing. This can be done with charcoal, or directly with a brush loaded with a very diluted paint, allowing for erasure and correction by rubbing with a cloth. At least one hour should be spent measuring. The first marks should be set down with confidence, and the construction of the drawing should be verified to be in the same proportional ratio as that offered by the model.

SUBJECT

The model is a dressed figure, shown in a particular situation from an aerial view in contrast to a more conventionally presented composition.

STEP 1

First, the background is stained with raw umber, spreading the pigment with a rag slightly moistened with turpentine. The background should be a uniform tone.

STEP 2

The figure is constructed on a base of a uniform color. The brush is only slightly loaded with paint so that the stroke can be as light as possible and hardly seen.

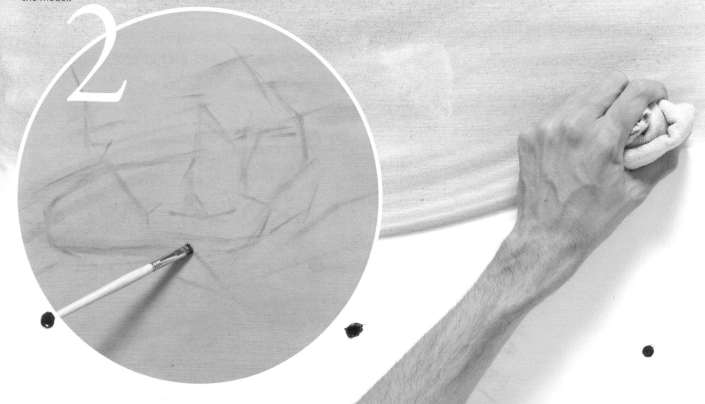

3

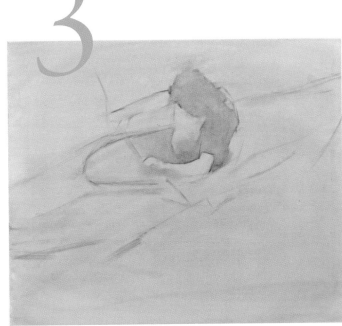

The preliminary drawing is made with raw umber. It is important to try different brands, as there are many varieties of warmth in color.

STEP 3

It is not only a matter of developing a line drawing with a brush but incorporating tonal areas as much as possible. The brush adds shading by making light blends without sharp contrasts.

STEP 4

The drawing is almost finished. The thin layer of diluted color allows the paint to evaporate quickly and does not obstruct the subsequent application of color.

4

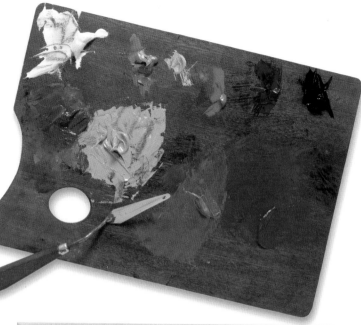

The colors are placed on the palette, and, with a metal palette knife, the first mixtures are made in an effort to create the basic color ranges as seen in the model.

These colors are stored on a separate palette to be incorporated into the work as painting progresses.

Preparation of the palette and staining in blocks

Once the drawing is finished, the color palette is prepared: titanium white, yellow ocher, cadmium yellow, light cadmium red, cobalt blue, and ivory black. The model is observed carefully, and then, with a metal palette knife, the colors are mixed until a range of mixtures is arrived at that matches the model. The first color stains will be very structural and blocky, and used to build the solid shape of the figure.

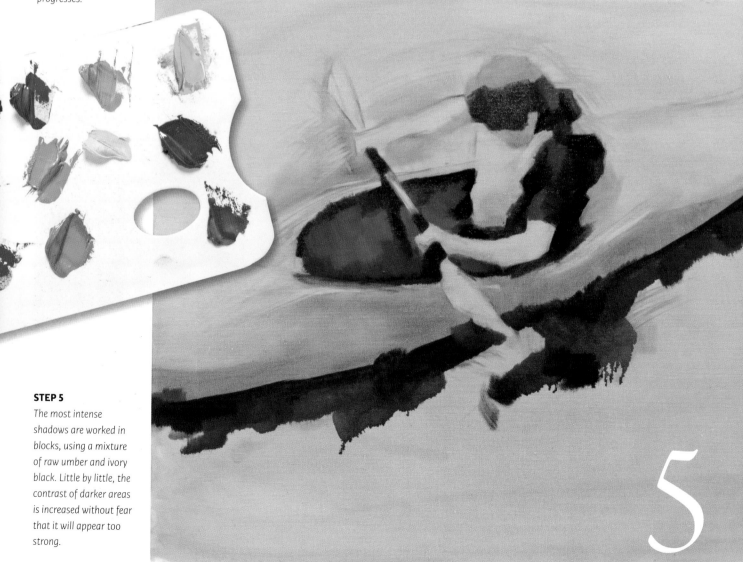

STEP 5

The most intense shadows are worked in blocks, using a mixture of raw umber and ivory black. Little by little, the contrast of darker areas is increased without fear that it will appear too strong.

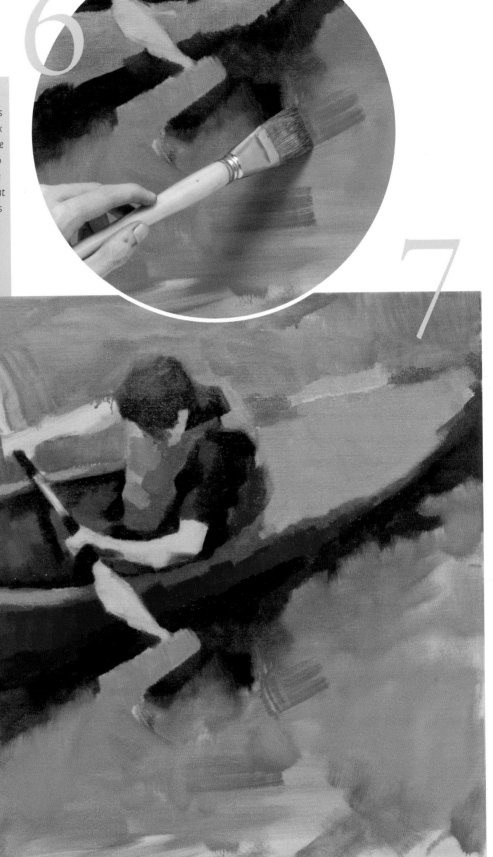

STEP 6

The background gray of the water is applied with a flat brush. The dark shadow and gray are blended together with the brush, caressing the paint gently in different directions with the bristles.

STEP 7

Red and carmine tones are added to the kayak along with violet to the vest and raw umber to the hair. Note that the color layer is mostly flat and covers whatever is underneath.

Time to paint the water

After sketching in and applying the initial colors of the figure, we begin to work on the water, which covers more than half the surface of the painting. Before approaching the texture, foam, and possible reflections of light on water, a base color is prepared. This serves as the background on which contrasts and the effects of turbulence and volatility of the water will develop.

STEP 8

On the base of gray paint, new tones are added, contributing variety and movement to the water. The flesh tones, the kayak, and the paddle blades are rendered loosely, differentiating between the light and shade areas. The video shows part of the process.

STEP 9

The figure is worked with a fine brush, blending the colors that make up the areas of light with those of shadow. The transitions from one to the other should be smooth and give the impression of modeling.

STEP 10

The figure is left for a moment to focus our attention on the water. The base of the kayak is darkened with new values of intense gray; the water stained with an irregularly distributed bluish gray.

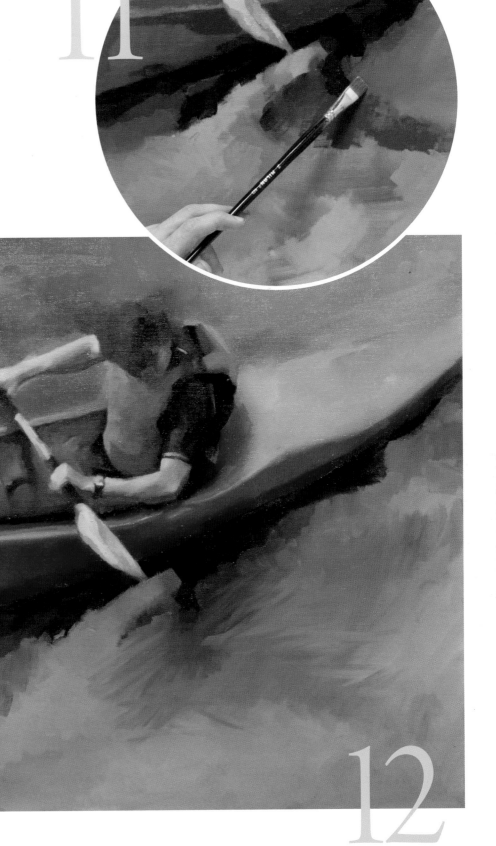

STEP 11

The different shades of gray covering the water are blended together to form smooth color transitions on the surface. The shadow at the base of the kayak remains dark.

STEP 12

It is very important to control the direction of the brush stroke, leaving linear marks and blends upon the water surface. This is only a color base upon which water currents and surface reflections will be painted later.

The posture of the body

What's interesting about a painted figure is that it doesn't necessarily depend on the physical appearance of the individual. It also depends on how the figure interacts with the background, and how clothing and other accessories change or emphasize a figure's shape (glasses, watch, vest, cap). Another important consideration is capturing a figure's posture to represent the action being performed, which in this case is the appropriate position of the body in the act of rowing. Then, it is time to work on details and textures.

STEP 13

Observe how the face has been developed and the glasses made more distinct. The vest collar and paddle are completed too, and highlights added to the kayak.

STEP 14

Dense brush strokes of different shades of bluish gray are applied to create the texture of the rough river surface. These strokes should be intentional, well marked, and suggest the movement of water.

STEP 15

The paddle blades are completed. Some blues are added to suggest the effect or surface ripples. Added last are brush scribbles of titanium white representing the highlights and foam produced by the movement of the kayak. You can see this technique in the video.

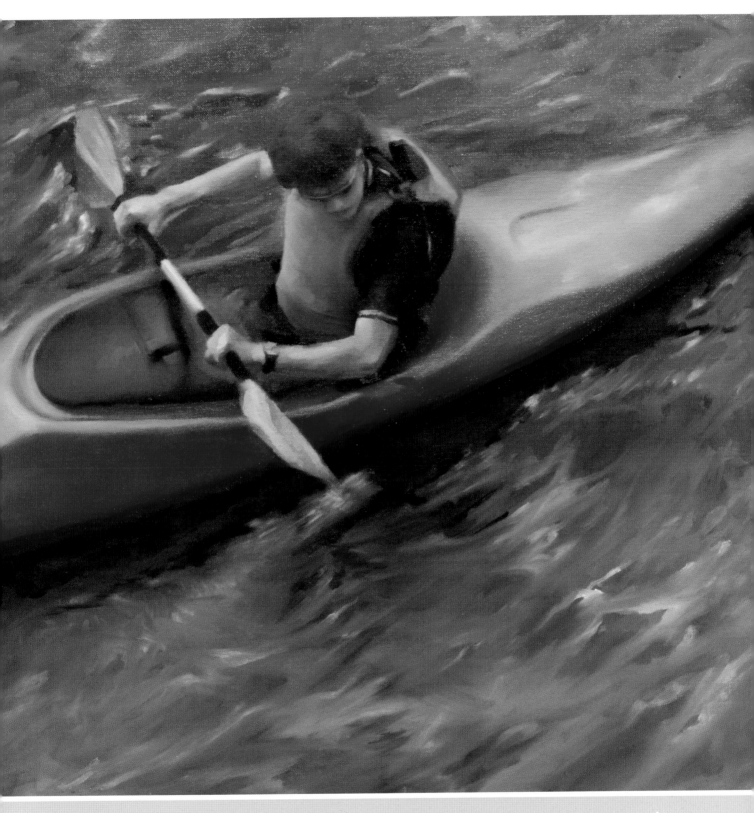

FINISHED STATE *While the paint is still fresh, strokes representing the water are slightly blended to convey speed of movement in the river. With a fine brush, detail is added to the character's face, the paddle, and the watch. The soft modeling of the kayak reveals the synthetic material from which it is made.*

IN DETAIL A SLEEPING BABY

When portraying children, proportions are not as constant as those of an adult. This is so because a child's body undergoes a process of constant growth in the first few years of life and its proportions are continually changing too. Usually, the length of a newborn is equivalent to three times the size of its head. There are also additional problems unique to the representation of children, such as their inability to remain still for long periods of time. To paint children, you should take advantage of those times when they are sleeping. The below watercolor was painted by Gabriel Martín; opposite page, *Sleeping Baby*, painted in oil by Mercedes Gaspar.

2.1

1. *Do not miss an opportunity to study the anatomy of children. Wait for them to tire and rest quietly and unmoving on a sofa, or when they have fallen asleep.*

2. *The figure of a child has rounded forms and flesh tones that are delicate and rosy. The modeling of the body, then, must be softer than that of an adult subject.*

1

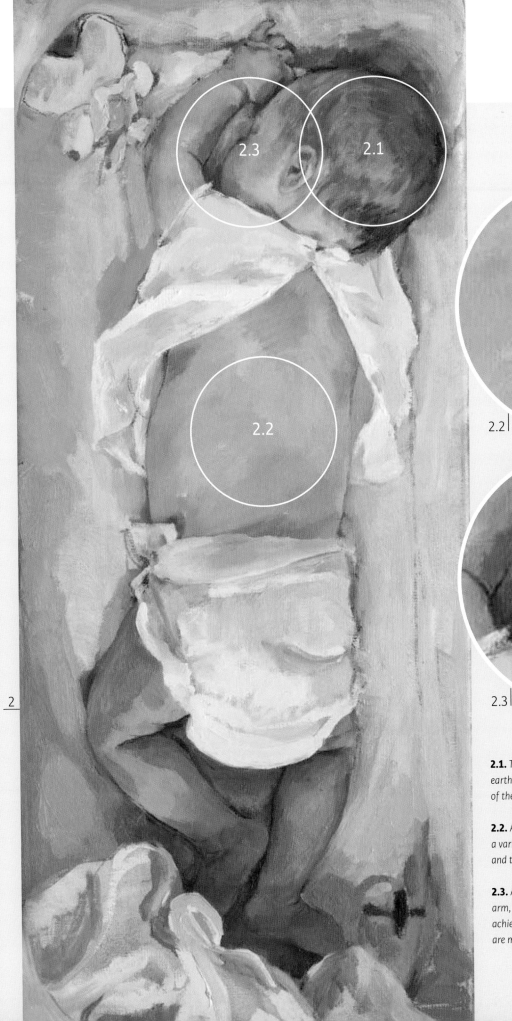

2

2.2|

2.3|

2.1. The hair is painted by applying brush strokes of earth color, more intense on the highlighted right side of the head.

2.2. A close look at the color tones of the skin reveals a variety of colors used by the artist, including violet and turquoise.

2.3. A fine line delineates the contour of the face and arm, which are close to each other. The rosy tones are achieved by adding English red, or red umber. These are most suitable colors for this purpose.

GALLERY:

ACADEMIC DRAWING AND PLASTER CAST MODELS

The study of the human figure begins in art school. With well-controlled lighting conditions and static models, the artist learns to observe, calculate, and draw the figure to proper proportion. The copying of plaster casts is a direct and comprehensive approach to understanding three-dimensional shape. The learning process begins with monochrome studies. Copying from old pictures and plaster casts offers a clear view of the distribution and modeling of light and shadow over a figure's face, head, or body.

1 Iago Remacha. *Plaster Figure.* Oil on canvas

The painting of plaster casts offers a solid step towards understanding something as complex as the three-dimensional representation of the human figure. With these simple exercises the artist can learn to measure, construct varied planes of light, and create the impression of volume. The purpose is to begin using a scale of values, predominantly white and gray, to subsequently render complex tonal relationships.

2 Iago Remacha. *Gypsum Head.* Oil on canvas.

Rendering three-dimensional plaster casts is an important stage in a realistic artist's development. Simplified to using only black and white, the study and rendering of plaster casts facilitates understanding of the model before progressing to flesh colors. Additionally, using plaster casts makes it easier to see contour lines due to the static nature of such a model, especially when placed against a black background.

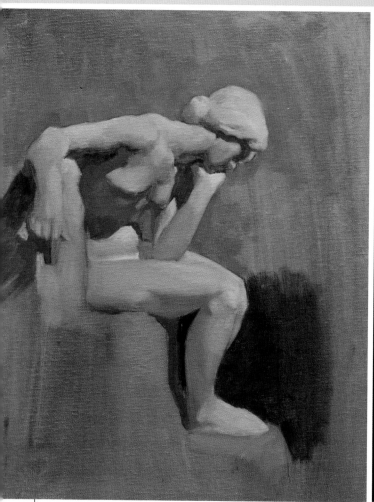

1

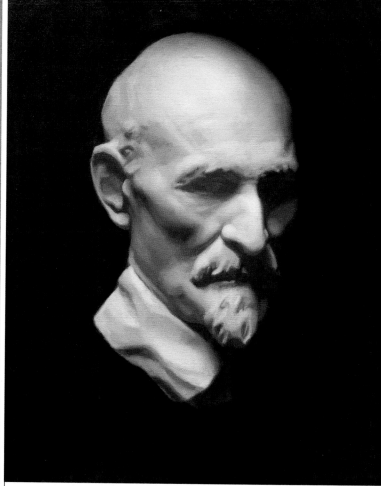

2

3 Iago Remacha. *Head.* Drawing in chalk.

Academic teaching requires the student knows how to draw from plaster casts and live models before working with color. Here, the anatomy of the face is described using a chiaroscuro effect. Strong lighting in varied black and gray shades on a black background results in a striking interpretation of the subject.

4 Christian Duran. *Male Figure.* Graphite.

Learning in academies and art workshops culminates with the study of the live model. Mastery of the human form is the ultimate goal of long training in the drawing process and is essential for realistic painters to accurately represent shapes in space. With a strong foundation in drawing, an artist will be an articulate painter.

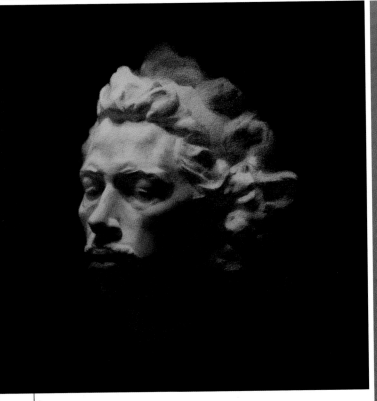

3

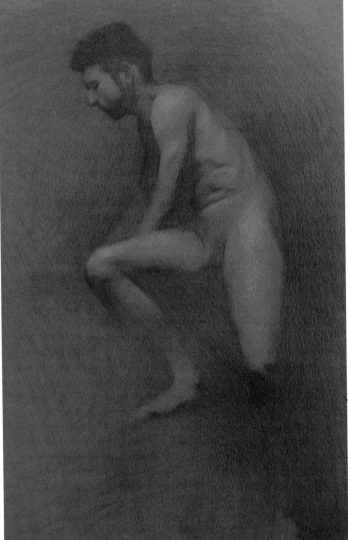

4

PORTRAIT IN WATERCOLOR

The next exercise is to paint the bust of a female figure, which includes the head and half of the torso. The composition does not focus exclusively on the face. While the focus is primarily on facial features, it also includes hair texture, the scarf, body posture, shoulders, and arms. The rest of the body and background are rendered with looser strokes and more uniform colors. Painting exercise by Mecedes Gaspar.

Inclination of the head

Before drawing, we must check the angle of the head's central axis. This angle is different with each model and is determined by the position of the body and direction of the gaze. In this three-quarter pose the head is angled towards something outside the frame.

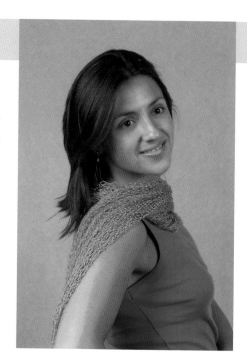

SUBJECT

A young girl in a three-quarter pose, her eyes directed out of the picture frame.

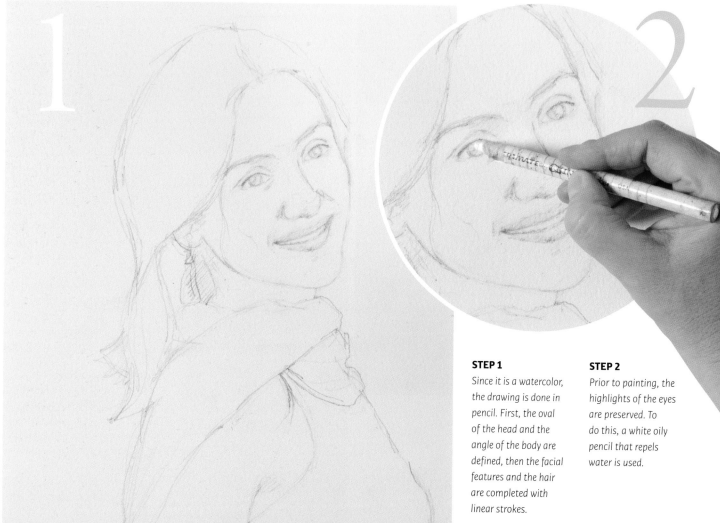

STEP 1

Since it is a watercolor, the drawing is done in pencil. First, the oval of the head and the angle of the body are defined, then the facial features and the hair are completed with linear strokes.

STEP 2

Prior to painting, the highlights of the eyes are preserved. To do this, a white oily pencil that repels water is used.

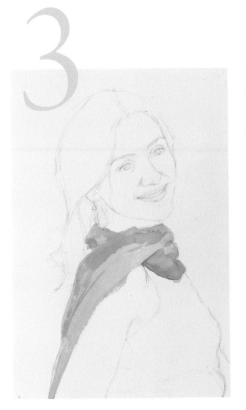

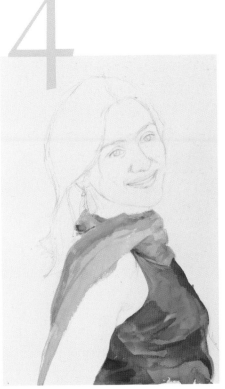

STEP 3

The scarf is outlined with two shades of green, basically differentiating the light and shadow areas. The blouse is covered with a saturated and uniform wash of titanium green.

STEP 4

When the green of the blouse has dried, new spots of emerald green mixed with a little carmine are added to convey shadows and give some relief to the torso.

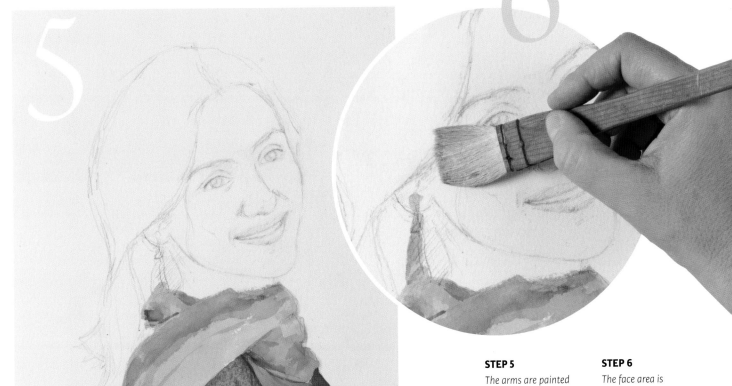

STEP 5

The arms are painted with transparent red umber, a little violet, and burnt umber. These colors blend to form the base color of the flesh.

STEP 6

The face area is moistened with a water-soaked flat brush before applying the colors. This will facilitate mixing the colors on the paper.

Base color for the face

The face is one of the most important parts of this painting. To get an accurate representation of the model, it is necessary to carefully plan how the different layers of watercolor will be applied. It is preferable to first lay out a base of colors applied on wet paper, then to articulate facial features using a finer brush and adding paint to a dry surface.

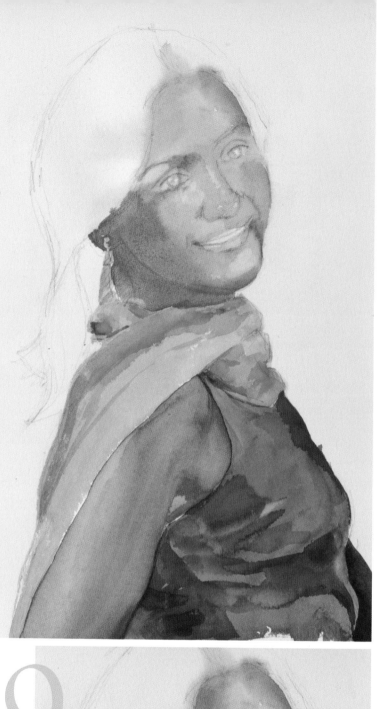

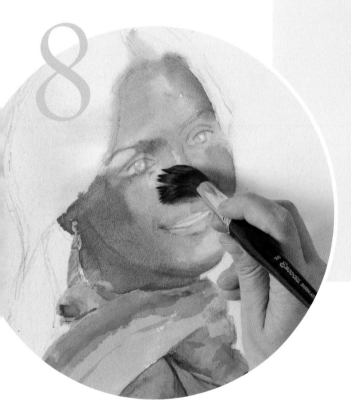

STEP 7

The flesh colors of the face—burnt sienna, ocher, and a touch of violet—are applied on wet paper. These colors spread out on the wet surface to form interesting gradations.

STEP 8

The lighter area at the center of the face is lightened by passing a dry brush over it. The brush will absorb some of the watercolor and uncover the underlying white of the paper.

STEP 9

We allow the wash of the face to be completely dried before proceeding to paint on dry paper. The outcome is greater depth in the shadows and the enhancement of facial features. Now the lips are painted. Watch the process in the video.

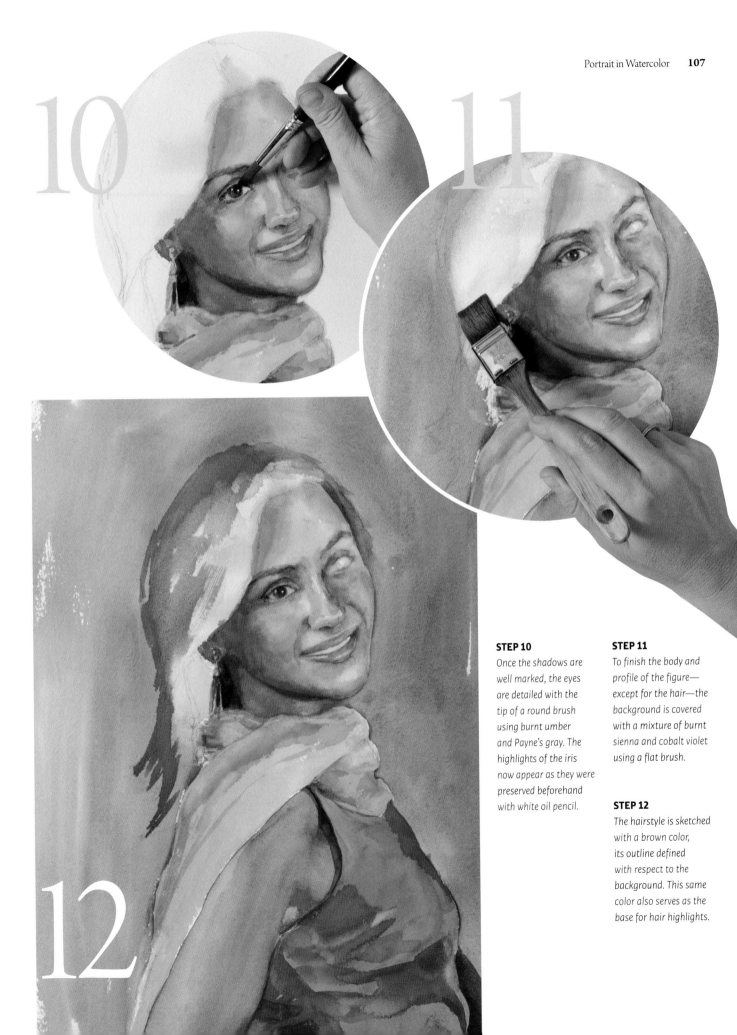

10

11

12

STEP 10

Once the shadows are well marked, the eyes are detailed with the tip of a round brush using burnt umber and Payne's gray. The highlights of the iris now appear as they were preserved beforehand with white oil pencil.

STEP 11

To finish the body and profile of the figure—except for the hair—the background is covered with a mixture of burnt sienna and cobalt violet using a flat brush.

STEP 12

The hairstyle is sketched with a brown color, its outline defined with respect to the background. This same color also serves as the base for hair highlights.

Texture of the hair and the scarf

Despite the progressive addition of detail to the face, the most striking detail in this last phase is the textural precision of the hair and scarf. Both surfaces require different applications and technical solutions. Watch this process in the video.

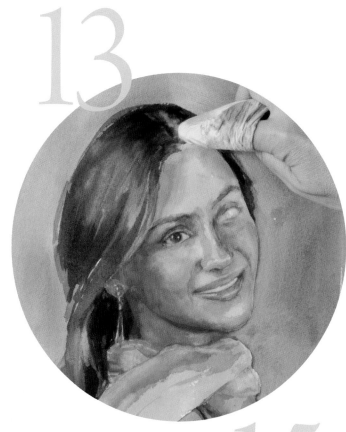

STEP 13

Brushstrokes of burnt umber are applied on a completely dry color base. Each brushstroke should describe strands of hair. To reveal highlights, part of the painting is removed with a cloth.

STEP 14

Working carefully with a fine round brush, the eyes are completed. Contours of the lips and nose are detailed. It is useful to have on hand a piece of absorbent paper to pick up excess paint. Watch the video to see the process of rendering the eye.

STEP 15

The texture of the scarf appears as a net and is left for last. With a fine brush the inner grid spaces—where the color of the skin comes through—are added. Some highlights are painted in using white gouache.

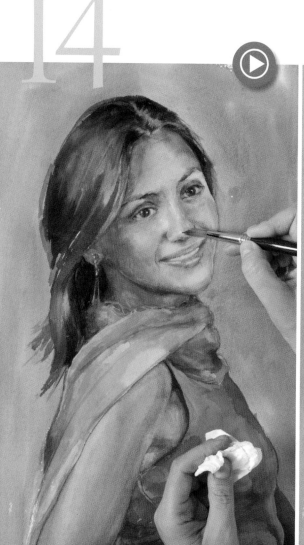

FINSIHED STATE

The only thing left is to apply some scarf detail and to darken hair areas with Payne's gray and burnt umber. Special care must be taken not to cover the light strokes that suggest the earring. The result is fresh and the flesh color is well worked and modeled.

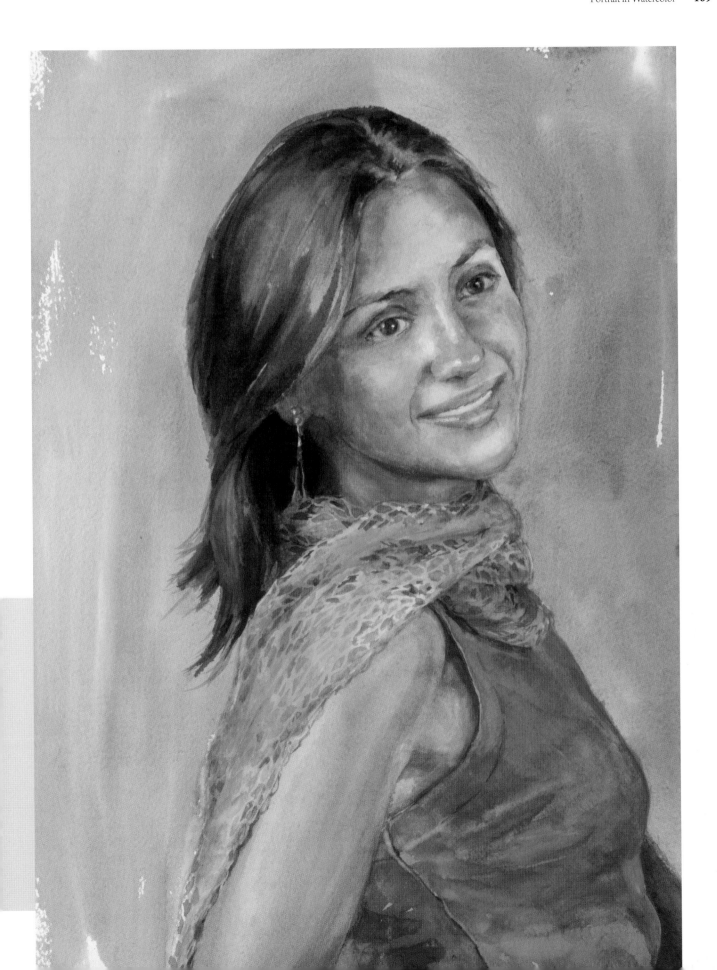

HOW TO DO IT:

PAINT WRINKLES ON A FACE USING ACRYLIC

Representing the elderly offers greater expressive possibilities than models of any other age. The physical features of the elderly are more pronounced, which makes drawing and constructing the face much easier. As people age, the skin loses elasticity and sags. This causes the underlying bone structure to be closer to the surface. The rough and limp texture of the skin generates many wrinkles, and each of these must be understood as a crease that generates a shadow. Painting exercise in acrylic paint by Isabel Pons Tello.

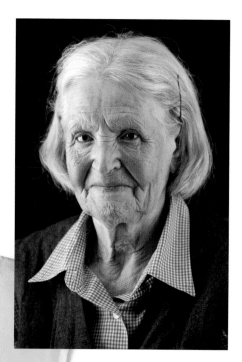

The face of an older woman is characterized by deeper eye sockets, loose eyelids, and prominent bone structure under a thin skin, especially at the cheekbones.

SUBJECT
An elderly woman with a warm smile, wearing cool tones that complement her hair and the background..

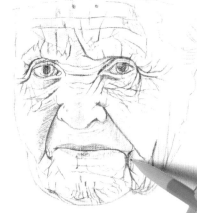

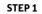

STEP 1
The drawing is done with a mechanical graphite pencil. An elderly face is rarely round and displays greater angularity with looser skin and highly visible wrinkles around the eyes and mouth.

STEP 2
Using the same mechanical pencil, the hair and blouse collar are drawn with linear strokes. Then, a very first watery brown color is prepared and applied to the face, except for the eyes.

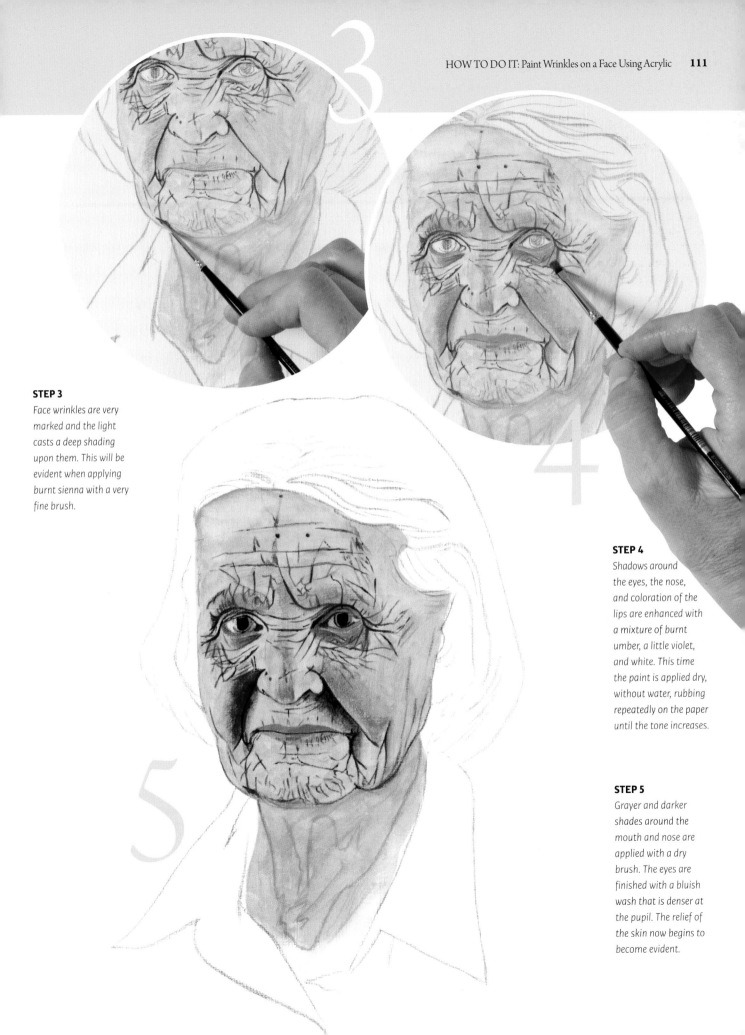

STEP 3

Face wrinkles are very marked and the light casts a deep shading upon them. This will be evident when applying burnt sienna with a very fine brush.

STEP 4

Shadows around the eyes, the nose, and coloration of the lips are enhanced with a mixture of burnt umber, a little violet, and white. This time the paint is applied dry, without water, rubbing repeatedly on the paper until the tone increases.

STEP 5

Grayer and darker shades around the mouth and nose are applied with a dry brush. The eyes are finished with a bluish wash that is denser at the pupil. The relief of the skin now begins to become evident.

Sketching to create focus

The goal of this exercise is to focus the viewer's attention on the center of the character's face. Using an atmospheric base of gray and brown colors, the hair, the blouse collar, and the background are left slightly sketchy. The lack of detail in these areas allows us to focus on the model's features.

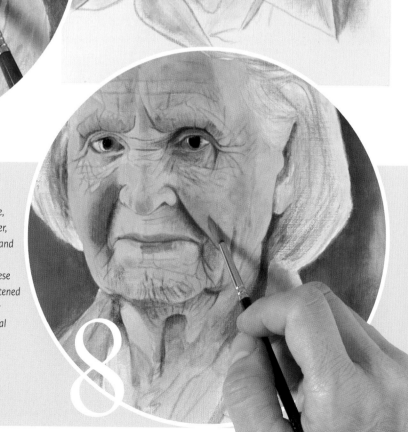

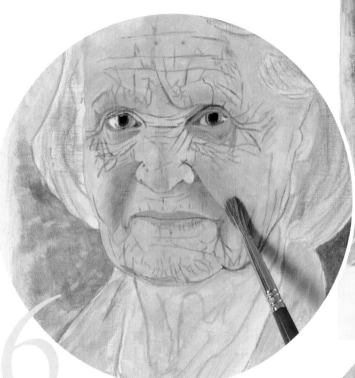

STEP 6

A thin wash of a very whitened ocher is applied to soften facial shadows and to pull things together. The background and hair are stained with grayed brushstrokes of cyan blue. This color is somewhat lighter on the hair and blouse collar.

STEP 7

Orange washes are applied to enhance the cheeks, the upper part of the mouth, and to give greater warmth around the eyes. The background is darkened with new brush strokes of ivory black applied with the dry-brush technique.

STEP 8

In the flesh-coloring phase, shades of ocher, burnt sienna, and even violet are applied. All these colors are whitened to give greater volume to facial features.

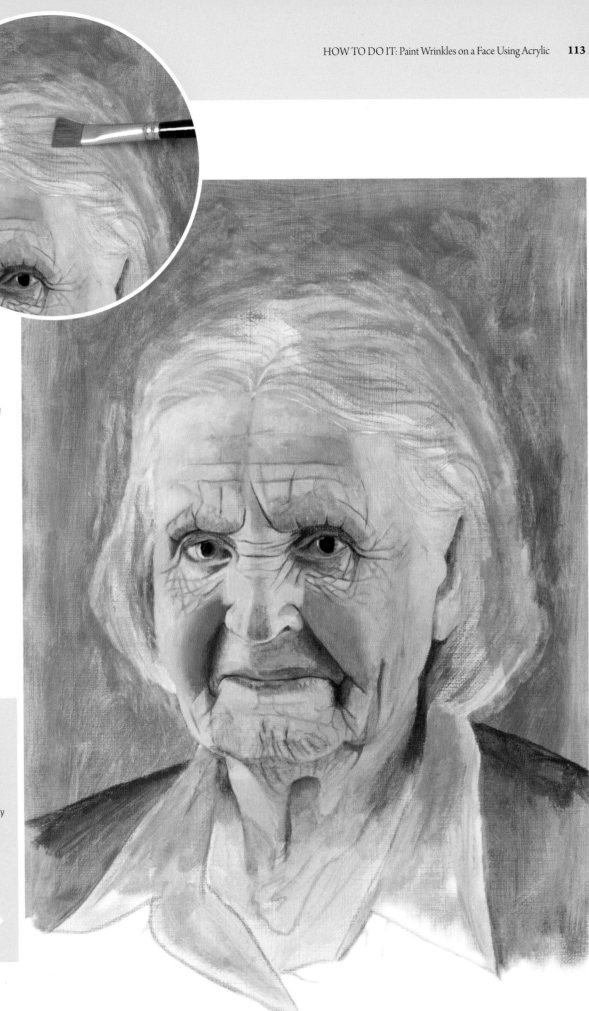

STEP 9

To keep the figure from looking like a cutout, a whitened gray is applied at the edge of the hair, which will help to blend it with the background. The shoulders are worked on as well for the same reason.

FINISHED STATE

To finish up, whitened tones are added on the left half of the face. The corner of the mouth and some wrinkles that might have lost intensity as the work developed are reinforced with a fine brush.

GALLERY:
PORTRAITS

Portrait-painting undoubtedly occupies one of the most exciting and privileged places in modern figurative painting. Painting a portrait is so much more than a mere detailed representation of physical form and not only about the individual features of someone's face. Hastily aiming to represent detail may render a portrait cold-looking and overly photographic. The success of a portrait depends on capturing features that reveal character and the inner world of the model.

1 Adrià Llarch. *Robin Williams.* **Gouache and pencil on paper.**

There is always a risk when portraying well-known performance or film characters. Since many fans have internalized the features of these stars, errors in likeness are easily detected. However, the following work is not conventional at all. It features a daring monochrome interpretation where washes are combined with gray, white, and black pencil strokes, and some touches of gouache. Realism need not always be photographic. This is an example of a more expressive and dynamic vision.

2 David Masson. *Portrait of a Young Woman.* **Oil on canvas.**

The modeling of flesh colors and a certain degree of blurred effect is the basis of this painting. The interpretation is complemented by a series of fine brush strokes, appearing on the face and on the shadows of the neck and lending a personal touch to the finish. In the background, the colors are blended to create a soft light effect reminiscent of those used in photography. The delicacy and simplicity of the flesh tones convey the idea of calm fragility expressed by the model.

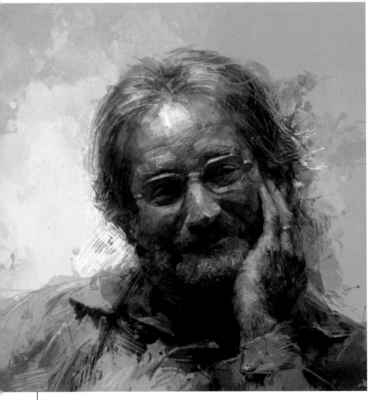

1

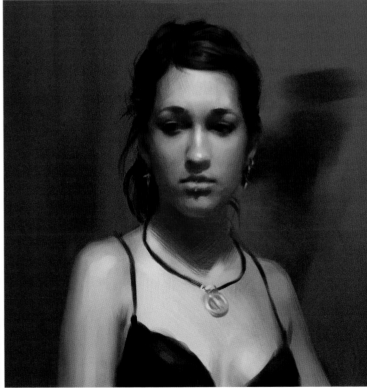

2

3 **Mohamed L'Ghacham. Portrait. Oil on canvas.**

In addition to capturing the character's features, painting a portrait also means rendering personality or mood. Contemporary figurative artists flee from the formal representation of the individual and often tend toward a more informal and casual manner of expressiveness. For example, contemporary painters might include characters in a domestic environment, which provides information about their activities or hobbies.

4 **David Masson. *The Girl in the White Dress.* Oil on canvas.**

While the flesh and the face offer a rich and well-modeled treatment, the dress and background appear somewhat sketchy. The artist worked with a paintbrush lightly loaded with paint to produce soft, fuzzy contours that are well integrated into the gray of the background without the figure looking like a cutout. The details of the dress are barely suggested, thanks to faint shadows and highlights. All these strategies are aimed at not taking away from the strength and importance of the face.

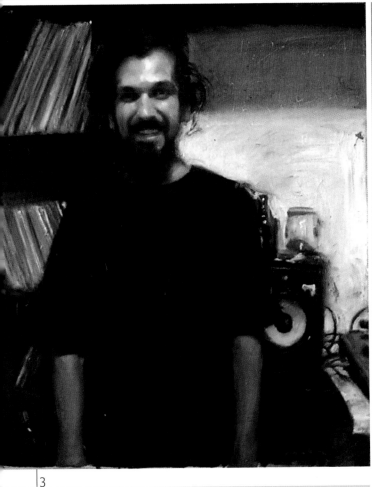

3

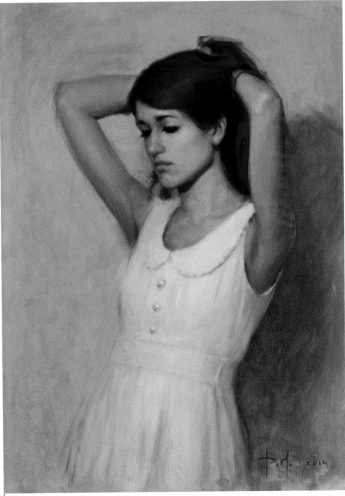

4

IN DETAIL: INTERIOR WITH FIGURE

1

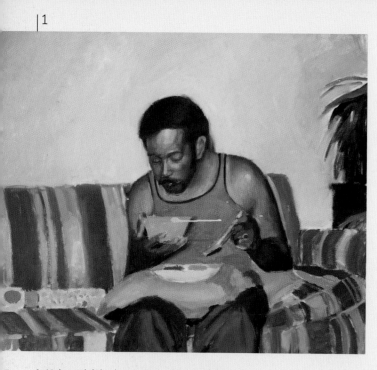

1. Mohamed L'Ghacham. Lunch. Oil on canvas.
Any time is a good time to portray a character, even in the middle of a lunch.
It should be noted that the artist has also reproduced the effects of the camera
flash. Incorporating photographic techniques into realistic oil paintings is a
common practice today.

2.1. *Note the quality of the flesh colors and the detailed folds of the clothing. The shadows are rendered with browns, carmine, and gray. In the light area of the face, small white highlights are featured that give a shine to slightly damp skin.*

2.1

2.2. *The drinking glass is vividly lit in contrast to the gray color of the background clothing. Whitened green, blue, and violet shades unfold whimsically in the glass, blending together with the orange and burnt umber colors that define the soda and ice cubes.*

2.2

2.3. *What is most interesting in this work is the surprising composition with the bar in the foreground, exhibiting all sorts of reflections and highlights. This is undoubtedly photography's influence.*

Most of today's realistic depictions of figures are drawn from everyday life. In fact, some of the best places to find subjects to paint are in public spaces such as bars, restaurants, cafés, coffee shops, and dance clubs. In these environments people act naturally, revealing aspects of their character and personality. Representing figures in an interior often means facing the challenge of rendering the perspective of the room or furniture through a portrayal that tends to the intuitive and is not too rigorous. Comparing the size of the figure with the objects of the background can be a practical method of achieving the realistic representation of the figure itself.

2. *Adrià Llarch. The Wait. Oil on canvas. The rich range of values that can be developed when integrating a figure into an interior atmosphere with its distinct light and color is far superior to the controlled tones of a photography studio or academic drawing classroom.*

2.3

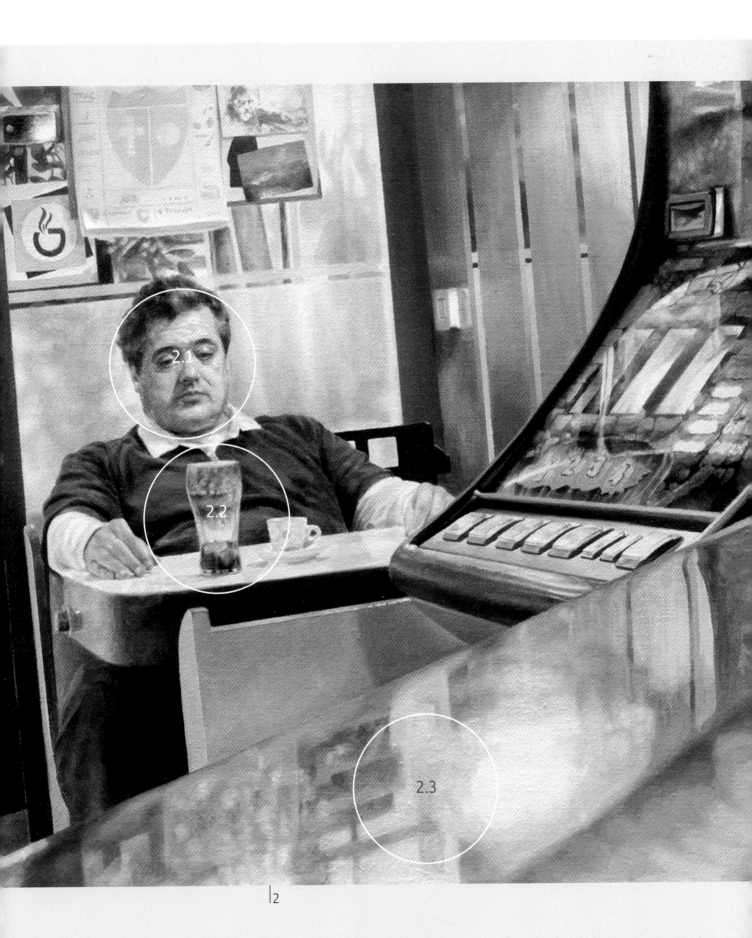

HOW TO DO IT:

MODELING FLESH COLOR

This simple exercise focuses on the nude as subject. It allows us to study both the chromatic range used to render human flesh and the modeling of the skin to achieve a volumetric representation of the body. It can be used as preparation for learning how to develop a range of chromatic skin tones, to study the most appropriate way to transition from light to shade, and prepares the student for a complex exercise to come. Acrylic painting by Isabel Pons Tello.

SUBJECT

A pose is selected where we can see a female torso bathed with a lateral light that enhances anatomical relief.

The flesh color of the model is intimately related to the colors surrounding it.

STEP 1

A mechanical pencil is used for drawing. The artist has chosen to apply a slight shading with very little contrast, which should not affect the first layers of acrylic paint.

STEP 2

The first goal is to cover the white of the paper very quickly with a mixture of ochre, carmine, and white, all very diluted in water. This layer is applied to the body of the figure, creating a base color on which to build the skin.

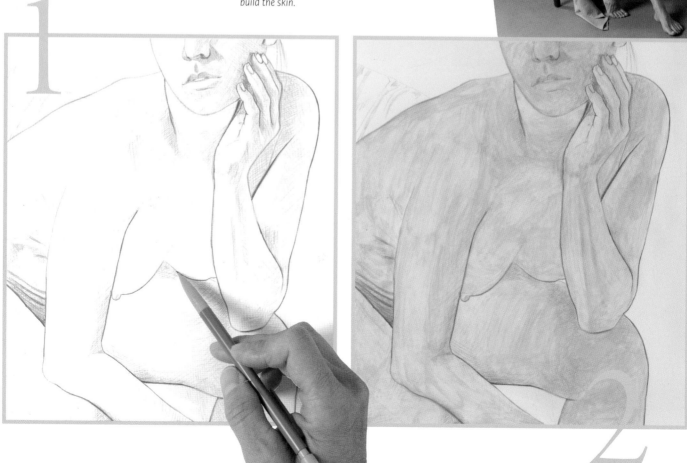

STEP 3

The same thing happens with the background. Layers of green and gray paint fill the spaces where the white of the paper is still visible. You must work carefully around the figure.

STEP 4

The background of the picture is defined with gray. Slightly more diluted, gray is also used to define the shadow on the figure. The color of the skin is intensified with a new coat of a semi-opaque paint made by mixing burnt sienna, ocher, and white.

STEP 5

Notice that the darkening process is gradual in its progression. The deepest shadows are contrasted with the mixture of burnt sienna and ivory black while warmer colors create contrast in the arms and knee.

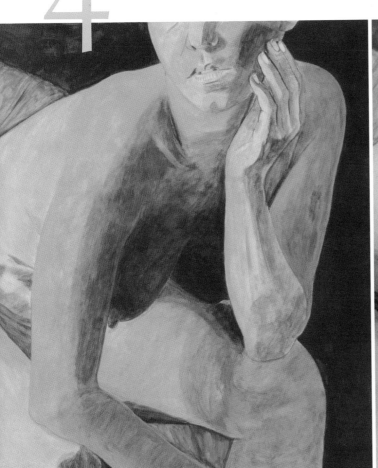

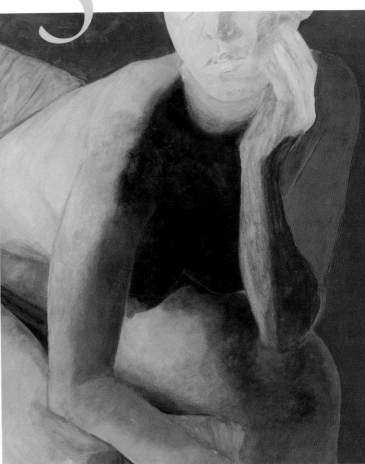

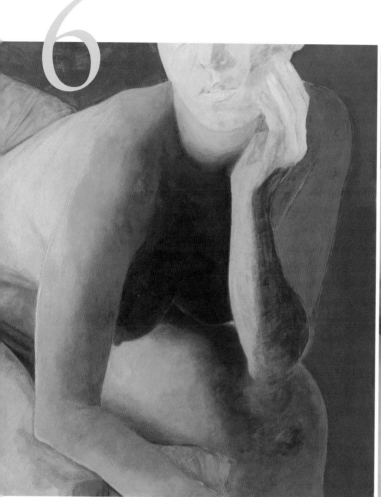

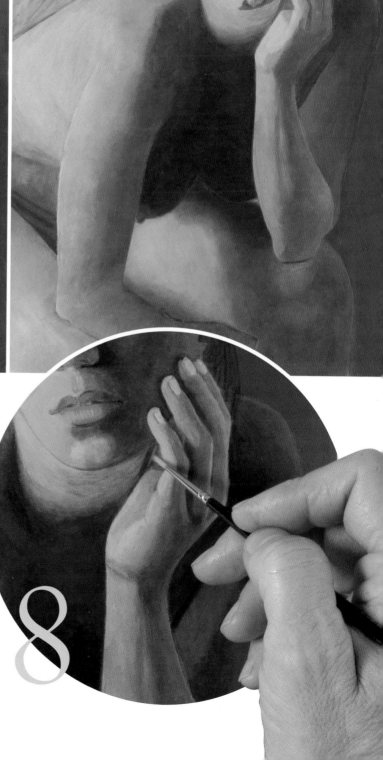

STEP 6

To model the flesh tones of a figure, it is advisable that the acrylic paint not be diluted. It is better to use a dense paint applied in thin layers that blend and mix with those adjacent. You must proceed quickly as acrylic dries quickly.

STEP 7

It is time to tackle the most delicate areas of the face and hand, which require more detailed work. The colors are applied in a sketchy manner with flat paint and without blending.

STEP 8

Once the main areas of light and shadow have been defined, a fine brush is used to better render the modeling, the volume of the hand and protruding lips and nose.

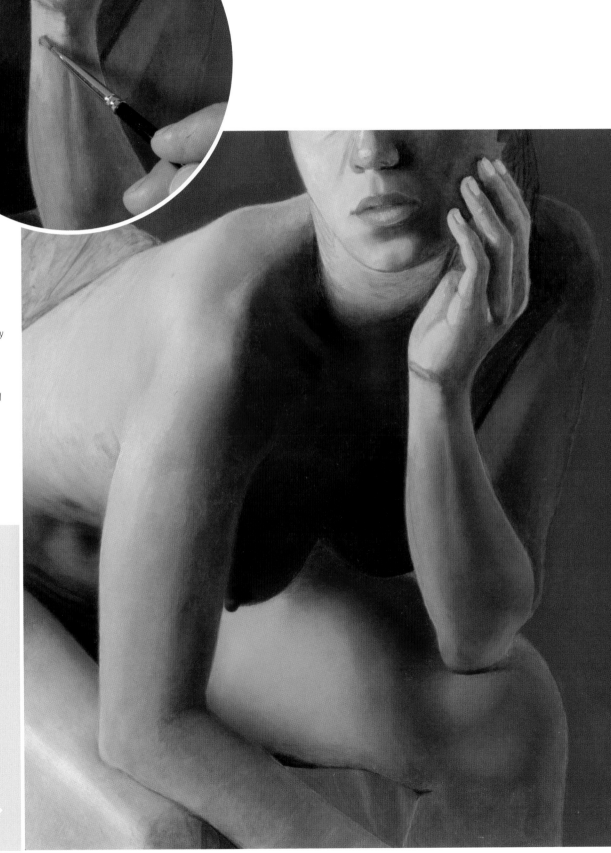

STEP 9

It is advisable to apply highlights gently so as not to lose the tactile, smooth, and soft quality of the skin. Highlights enhance the relief effect of the figure, and adding them is left until the end.

FINISHED STATE

The flesh tones of a nude should always be at the service of expressing anatomical light and shadow and will vary depending on the color surrounding the figure.

PAINTING A NUDE WITH THE SIGHT-SIZE METHOD

The Sight-Size comparative method, discussed in the first part of the book (see page 14), is a procedure that is used to achieve accurate results when drawing a model. It consists of establishing a position where the artist sees both the model and the drawing as being of similar size. Without using either mechanical measuring tools or external measuring elements, the artist transfers the model to the canvas using a 1:1 scale. This exercise was executed in oil and aims to achieve a hyperrealistic result. Painted by David Masson.

The comparative method

The photographic image of the model and the canvas are comfortably mounted on an easel. Both surfaces should be an equal 1:1 ratio in relative size. The only measuring tool used is a plumb-line or the handle of a brush, which functions as your ruler. The first step is to study the model and place marks and measurements at the canvas margins to aid in accurately constructing the drawing.

SUBJECT

This is a female nude with good lateral light on a gray background. All interest is focused on rendering the profile of the head and on working out the modeling of the flesh colors.

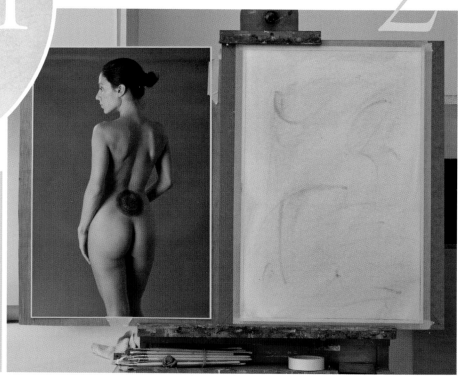

STEP 1

Before starting, the canvas is prepared. The background is stained with some raw umber, which is spread over the canvas with a rag moistened with turpentine.

STEP 2

The model image and the canvas are placed on a plywood board next to each other. The advantage of this method is that to compare paint and model it's only necessary to take a few steps backwards and gaze quickly from one surface to the other.

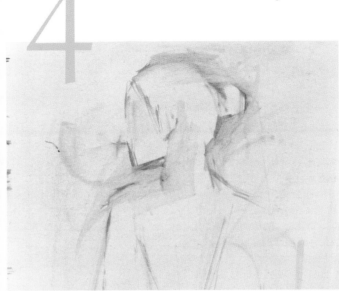

STEP 3

The artist studies the relationship of measurements and proportions on the model and transfers these as small marks placed on the top and side of the canvas.

STEP 4

Note that the marks correspond to the height of the head, nose, chin, and shoulders. In this fashion the profile of the head is constructed with confidence.

STEP 5

Similar marks register the position of the elbows and hips. With a watery brush loaded with burnt umber, some light, first lines of the figure are drawn.

Tonal drawing

The construction lines are completed with stains of color diluted in turpentine, beginning the shading. The entire drawing is constructed with fine layers of paint that can be erased with the quick wipe of a cloth. This avoids the tricky problem of soiling colors with charcoal dust.

STEP 6

With more intense strokes, some of the figure's outlines are sharpened while also applying the first tonal stains. Oil paint diluted in turpentine dries very quickly.

STEP 7

It is not about enclosing the whole body in silhouette with a dark line. The intense strokes are applied in spots, appearing only where shadow or contrast will be deeper

STEP 8

As the figure emerges little by little so do the background color glazes, which are necessary to highlight the body's illuminated profile.

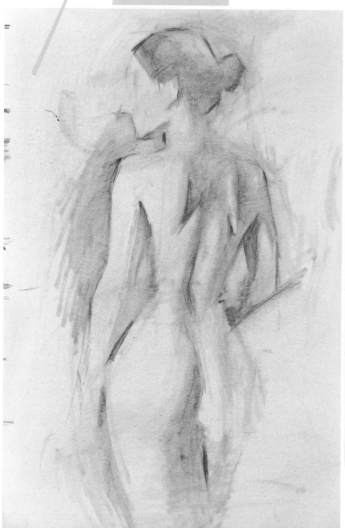

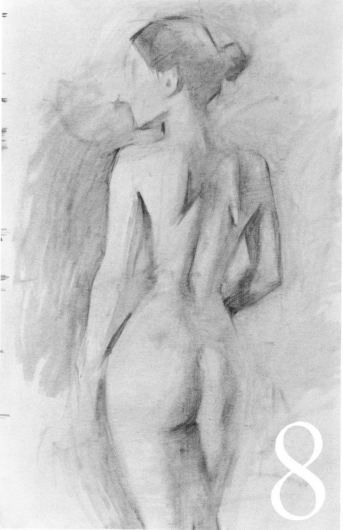

STEP 9

The tonal construction of the human figure provides a secure frame from which the profile of the head and the intensity of the hair begin to take shape. The anatomy of the back is finely tuned with new linear brush strokes.

STEP 10

It is time to incorporate color onto the figure, but before doing so, it is necessary to darken the background with a medium gray. The aim is to highlight the contour of the body and provide more sense of light on the flesh.

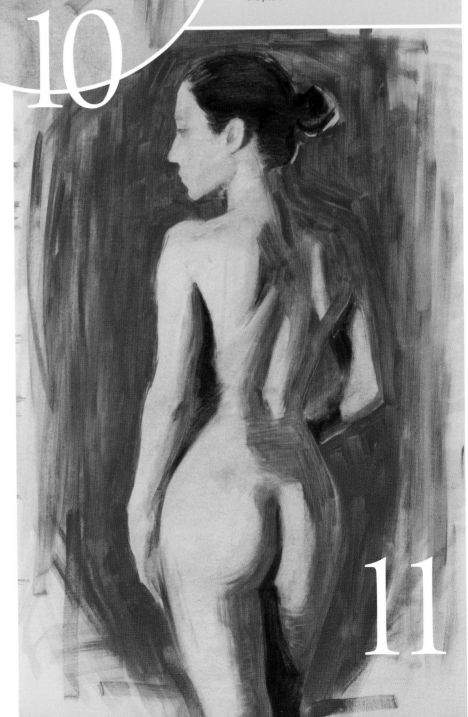

STEP 11

The layer of gray paint is constructed with a set of expressive and faded brushstrokes that, little by little, build up around the model. The shadows of the body are intensified with raw umber.

The artist prepares the palette with raw umber, madder carmine, ivory black, cobalt blue, English red, cadmium red, yellow ocher, and white.

Adjusting the flesh color

After first applying a monochrome raw umber to the figure, the flesh colors are then built up. To do this, you have to prepare the palette with the right colors and make accurate color blends using a palette knife. When you have a mixture ready, the spatula is loaded with a color and compared to the photographic model. To check accuracy, this is done with each color.

STEP 12

Mixtures are made with the palette knife: English red, a pinch of ocher, raw umber, and a little white to get the color of the skin. The palette is then brought close to the photographic model to compare for accuracy.

STEP 13

Oil stains are spread, rendering and covering each plane with a uniform and compact tone, without making blends or gradations with adjacent colors.

14

STEP 15

In this phase it is very important that the brush drags the paint to follow the contours of the body. The hair appears as a darker mass, and the facial features begin to emerge.

15

Mixing is done on the palette. Ocher or English red are added, little by little, to impart warmth to the shades. These are darkened using carmine or raw umber. It is very important to identify each tone in the model to find its equivalent on the palette.

STEP 14

As the body is covered with chromatic flesh variants, the edges of each stain are blended with a soft-haired brush. The modeling phase now begins.

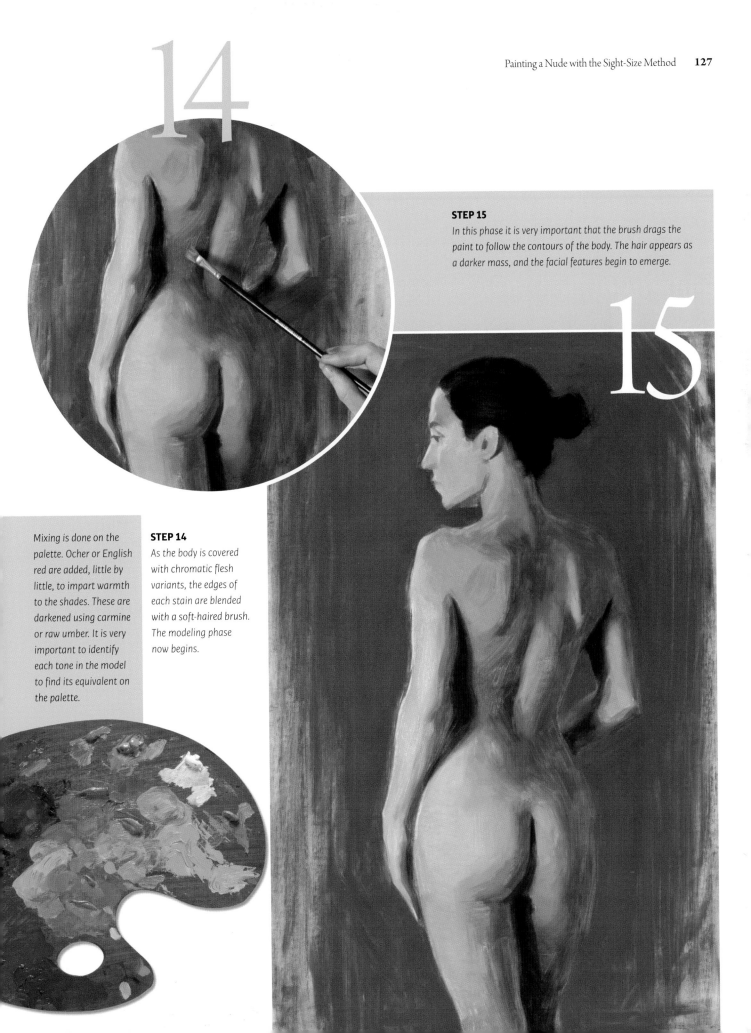

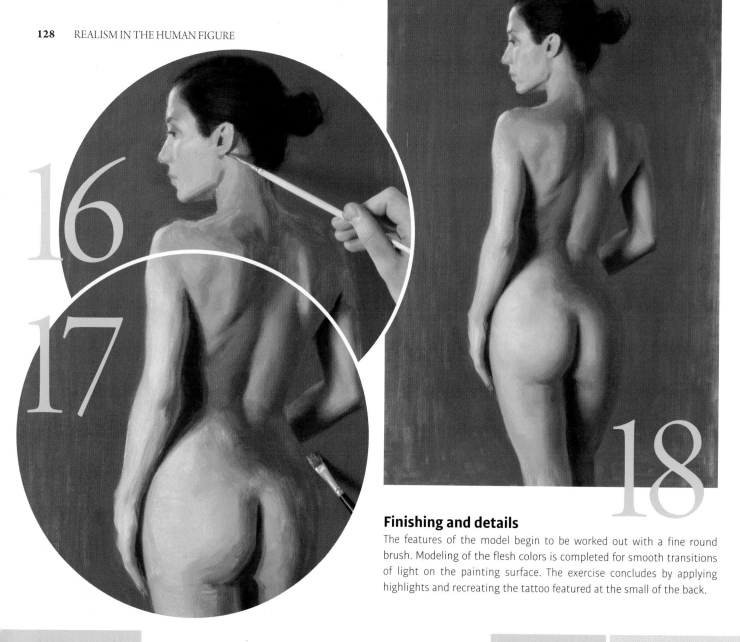

Finishing and details

The features of the model begin to be worked out with a fine round brush. Modeling of the flesh colors is completed for smooth transitions of light on the painting surface. The exercise concludes by applying highlights and recreating the tattoo featured at the small of the back.

STEP 16

With a fine brush, more depth is given to shadows of the ear and the eyes are better defined. The hair features gray highlights and trace of dark strokes to suggest the direction of the hairstyle.

STEP 17

Modeling work continues on the body with a special emphasis given to the back. The figure now offers a much more sculptural consistency. With further applications of gray, the background is completely covered.

STEP 18

This gray reverberates in the shadows of the figure, which are darkened with the same color, integrating and blending it with the warmest pinks of the flesh. Higher contrast between light and shadow translates into a much greater sense of volume.

STEP 19

With the same fine brush, the tattoo is drawn. It does not have to be sharply drawn and might even by somewhat out of focus, but it must be well integrated with the underlying colors.

FINISHED STATE

The finished work is clean and carefully executed. The artist has attempted to bring this painting to a high level of photographic realism, reproducing the model precisely and carefully in shape, light, and color.

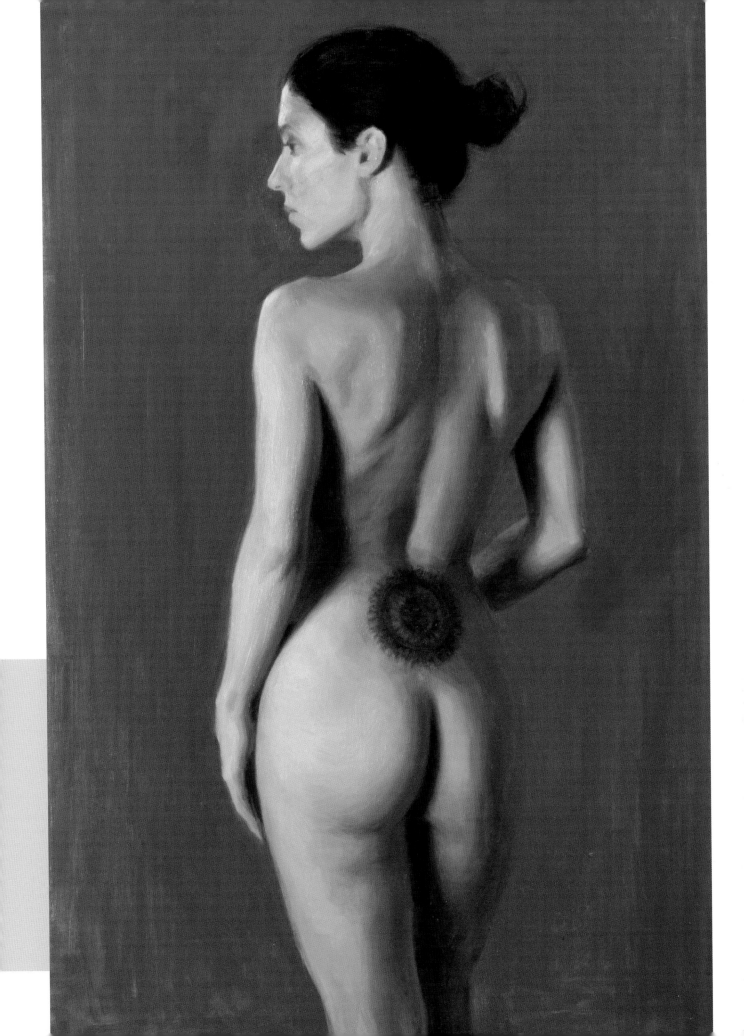

GALLERY:
NUDE FIGURES

The great chromatic problem in painting the nude figure is the creation of plausibly accurate skin color. Depending on light conditions, skin color changes and should be adjusted to reflect those changes in different paintings. Some colors are common to all manner of flesh while others usually appear only in the shaded areas of skin. Colors should be modified and restated as they are painted, progressively softening, correcting, or intensifying the color as befits the subject.

1 Christian Duran. *Nude Male Figure.* Oil on canvas.

Light is an inseparable component of shape, and the anatomy of the body is only made visible by the effect of light. In this case, the body is marked by a strong chiaroscuro effect—the most dramatic of illuminations—featuring deep shadows that almost merge the outline of the figure with the background. This effect is often used to intensify the drama and expression of the nude.

2 David Masson. *Figure.* Oil on canvas.

One possibility, when working out a range of flesh colors, is to play with the colors surrounding the figure. With contrast, flesh color is enhanced. Here, the figure is surrounded by shades of gray, making the flesh tones seem warmer in comparisonthan if the background were painted withreds and yellows. Whatever the case, it is best to consider the inner and outer colors together.

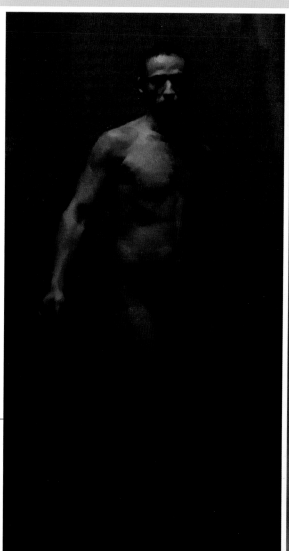

1

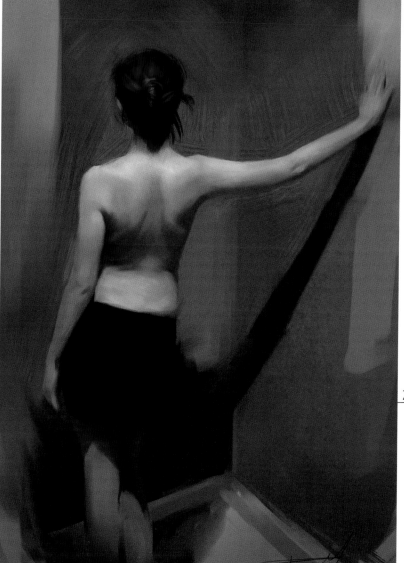

2

3 **Iago Remacha. *Nude Male Figure.*
Oil on canvas.**

When the light comes from a lateral source, it leaves the opposite side of the model in shadow and volume is enhanced by highlights. Each artist interprets flesh tones in a personal way. Some painters start from ocher as a base color. The nude shown here is based on a range of English red, sienna, and ocher, lightened with a cold white. Also, notice how the background gray appears on the shaded areas of the skin.

4 **Christian Duran. *Full-Figured Nude.*
Oil on canvas.**

Today, realistic painting seeks singularity, not perfection. Models who are unique in size break with routine, especially when academic proportions are honored and the painting is rigorous. Drawing a full-figured individual allows for varied proportions and a challenge in painting flesh quality, which is much looser due to the effects of gravity. Such a figure acquires a greater impression of volume, and bone references are barely visible on the skin.

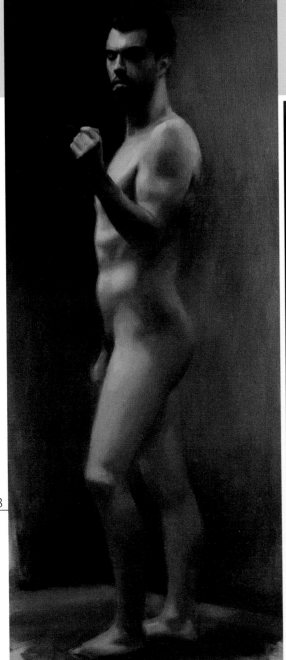

3

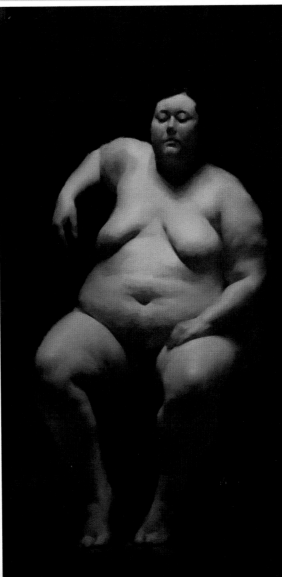

4

IN DETAIL: BLENDED FLESH TONES

There is no universal flesh color. Pictorial flesh tones are interpretations of skin quality under light. Shadows applied to skin can be dense and deep, or clear and transparent. Executed with soft strokes, they create an interesting blended effect. Here is an example of paint applied in soft glazes, in a blended and nondetailed fashion. These glazes aim to capture the anatomical relief of the body and also to immerse it in the atmosphere of a particular environment.

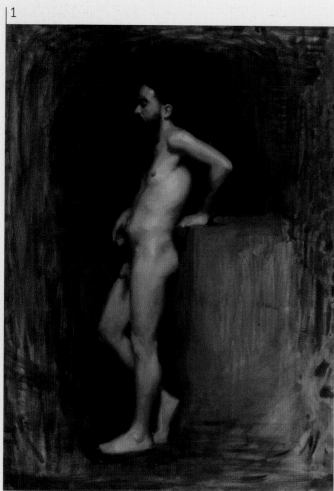

1. *David Masson. Nude Male Figure. Oil on canvas.*
Many artists avoid rendering well-proportioned figures, muscled bodies that are a measure of academic beauty. Instead, they prefer to paint the bodies of ordinary people and move away from stereotypes imposed by the world of fashion and advertising media.

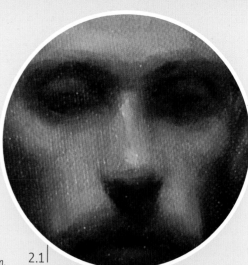

2. *David Masson. Nude Figure Sitting. Oil on canvas.* The most illuminated areas of flesh emerge from a dark background, highlighting the muscular anatomy and bone structure of the character. These contrasts are fundamental to conveying a three-dimensional impression.

2.1|

2.1. The face is developed with imprecise brushstrokes without linear strokes. The transitions from one tone to another are progressive, which gives a blurry appearance to the features.

2.2. The contrast between light and shadow becomes more evident in the hand. Despite this, details are minimal: just a whitened brushstroke to describe the fingernails and some dark brown touches between the fingers to give them depth.

2.2|

2.3. The paint, delicately applied, softens the contours of the figure and blends the color of the flesh with that of the background. It is necessary to work with soft-hair brushes.

2.3|

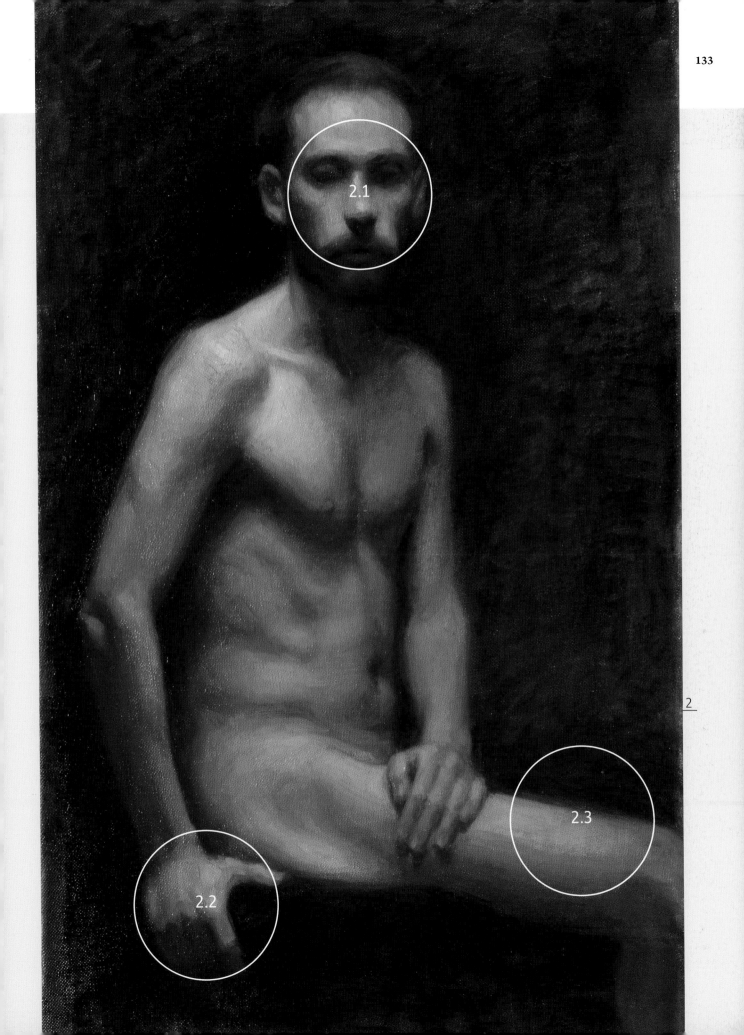

2

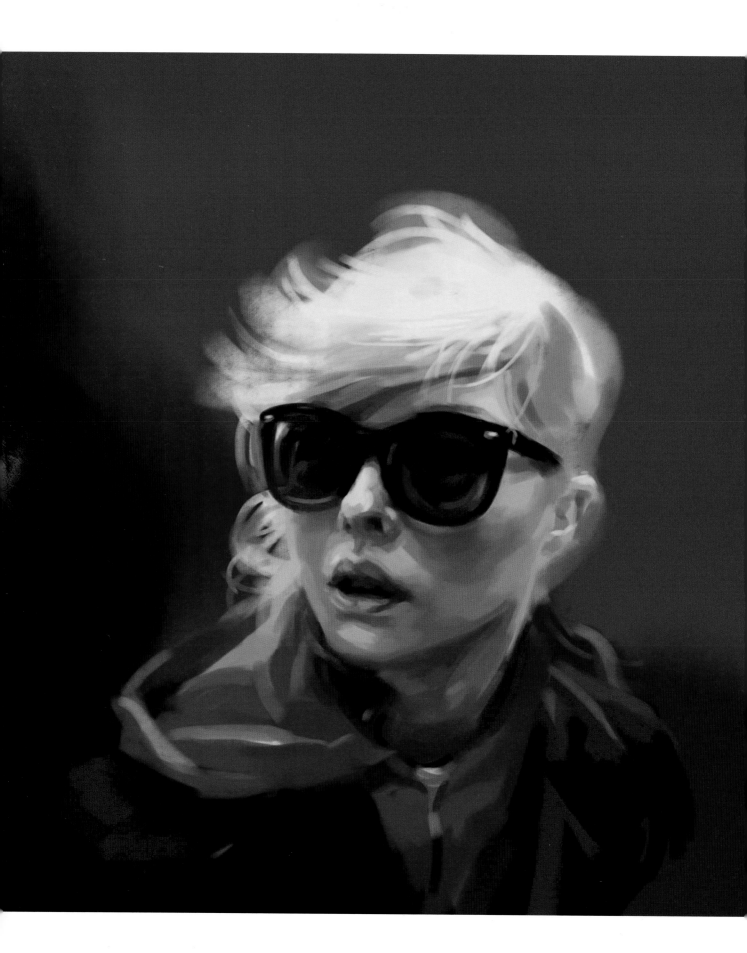

Methods of work

Before finishing this book, we will review concepts that are relevant to the process of building a painting, including drawing, composition, and the handling and mixing of colors. Being proficient with these concepts is essential to achieving the necessary discipline required of realistic representation. The goal is to acquire greater confidence and to be clear about each step that must be taken.

Realistic painting, especially hyperrealism or photorealism, requires great attention to detail and demands many hours of careful work to ensure a successful outcome. Advancing through the stages in building a successful painting only works if each stage is accomplished with satisfactory results. This is an art best suited to those with a patient nature.

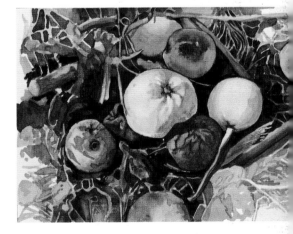

Adrià Larch. Blondie.
Oil on canvas.

DRAWING IS FUNDAMENTAL

The purpose of realism is to convey visual objectivity through a careful drawing that combines technique and discipline in portraiture, still life, and landscape. The "problem" with realistic drawing is that reality cannot be modified to accommodate a subjective vision. The model must be worked on with the aim of faithful reproduction, respectfully imitating what is seen with an allowance for small nuances.

1. *Christian Duran. Three Faces. Drawing. In this work, the artist combines the silhouetted drawing of the contours of the figure with delicate tonal treatments.*

2. *The techniques of rubbing with charcoal, pencil, or chalk are those most used by figurative artists. Artists should use the medium with which they can most comfortably work.*

|1

|2

Drawing using rubbing techniques

Pencils, chalk, and charcoal are artistic tools reserved for quick and shaded sketches. But the power of these tools, when applied to making realistic drawings, can be surprising. Featuring subtle effects, deep shadows, and fine detail, amazing works can be created with a pencil. We must learn to combine detail with diffuse or unfinished areas, which might be completed by the viewer's imagination.

Contour Drawing

A contour drawing is made following lines that define a model's silhouette. Initially, those lines are used as a guide to define shape and to indicate placement for each element. Once the silhouetting of the object has been accomplished with soft, transparent lines, these lines are integrated into the painting with the application of the first tones. They are easily camouflaged and eventually disappear almost completely.

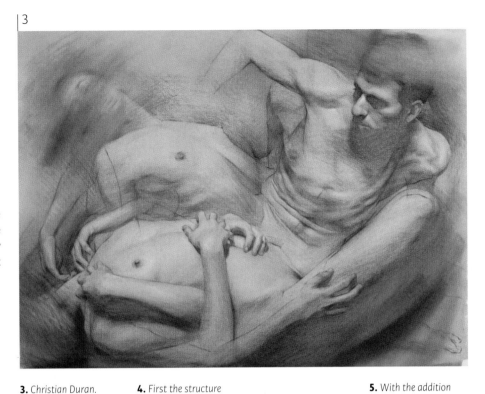

3

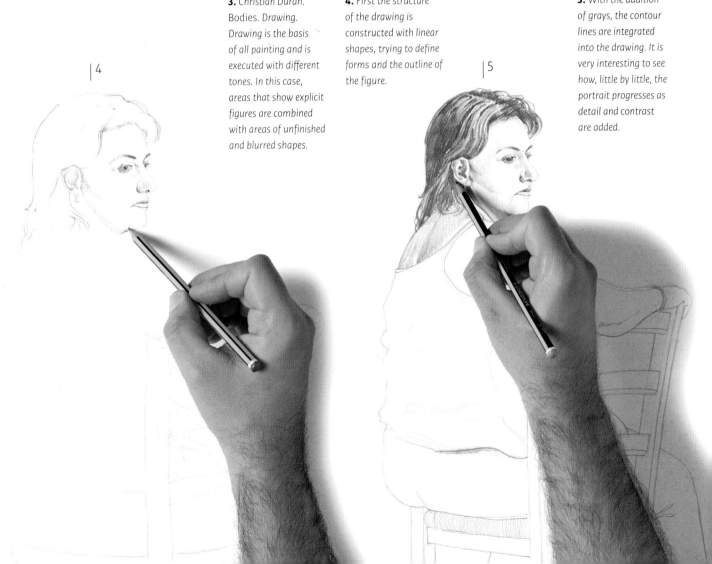

4

5

3. *Christian Duran. Bodies. Drawing. Drawing is the basis of all painting and is executed with different tones. In this case, areas that show explicit figures are combined with areas of unfinished and blurred shapes.*

4. *First the structure of the drawing is constructed with linear shapes, trying to define forms and the outline of the figure.*

5. *With the addition of grays, the contour lines are integrated into the drawing. It is very interesting to see how, little by little, the portrait progresses as detail and contrast are added.*

WORKING FROM PHOTOGRAPHS

If there is concern about the live model moving too much, or if there is no possibility of drawing or painting a live model, a good photograph can be used instead. Although it is not the most appropriate learning tool, it offers similar results with respect to the final drawing.

1

1. Photography allows people to begin the practice of realistic painting in a controlled and progressive manner, although it is always better to work with a live model.

2

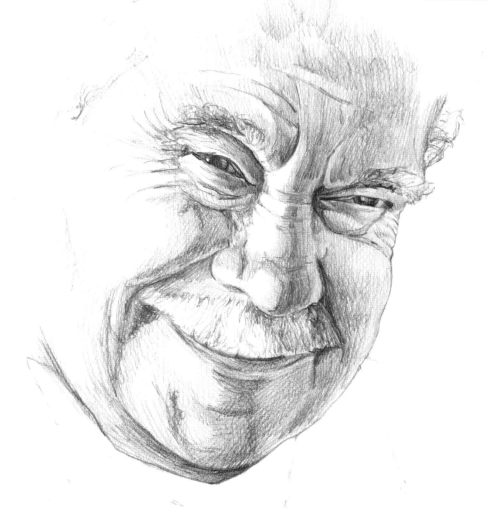

Photorealism

If you want to tackle a photorealistic drawing or painting, it is much easier to work from a photographic model. Such a model allows you to advance at your own pace, make enlargements to better see detail, and take the necessary time to make corrections, resulting in maximum likeness. Photorealistic artists aims to capture a subject in great detail, including reflections, imperfections, cracks, and even drops of water. In the realm of portraiture, photorealism reveals all possible skin imperfections.

2. Photorealism requires a detailed approach to the model in which all the features and skin imperfections are revealed.

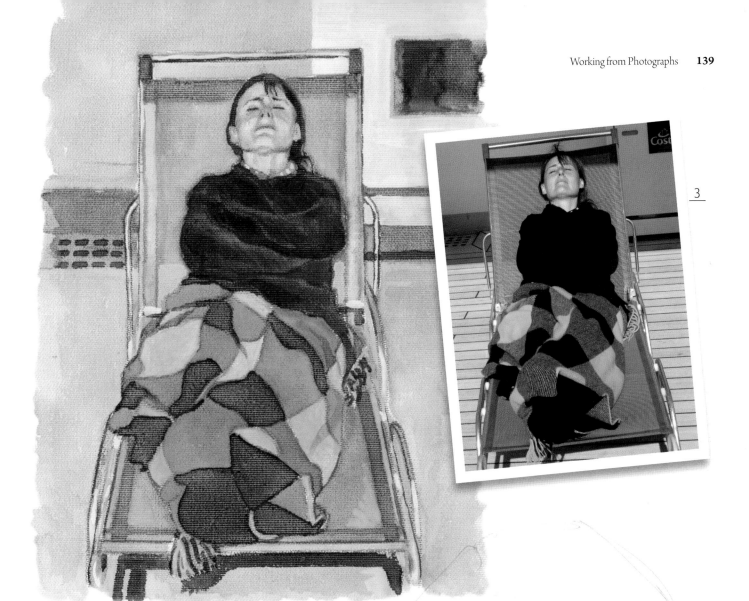

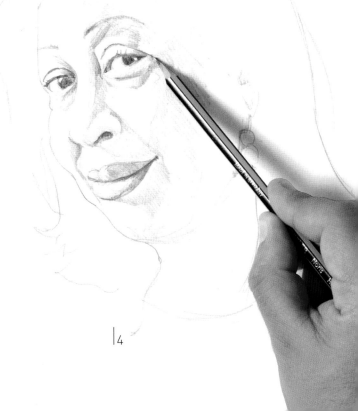

Drawing what you see, not what you think you see

One of the drawbacks of drawing pictures from photographs is that you must be sure you are drawing what you really see and not what you think you see. The human brain will generalize images, so you have to pay attention to detail and recreate what the brain tends to eliminate. This is the only way to obtain realistic images.

Rotating the photo

One technique for drawing what you really see, rather than preconceived shapes, consists of turning the photograph upside down. This technique tricks the brain into seeing actual shapes, and makes you disregard what you think an object is supposed to look like. This technique will help you draw those unique shapes you actually see.

3. *Working from a photograph allows the artist greater control with respect to the size and proportions of the model represented.*

4. *Draw what you see, especially when it comes to portraits. The human face is not symmetrical. For example, one eye is often higher, or bigger, than the other.*

ARTIST'S COLOR PALETTE

The realistic illusion of a well-designed drawing is an excellent base for incorporating the color evident in the real model. When painting, it is best not to try and understand color from theory, but to find it present in the model. Contemplate color in silence. Learn to see it little by little and train the eye. This means developing a painting informed by the sense of sight, not theory, and achieving results by comparing and adjusting tones, as much as possible, to those of the real model.

Color desaturation

When painting in a realistic style, a range of desaturated rather than pure tones are used. Colors are desaturated by mixing them with a bit of black, white, gray, or raw or burnt umber. The result is a softer range of colors best adjusted to represent reality. The beauty of color lies in its range of possibilities.

1. Realistic artists welcome the use of Payne's gray or black, which they usually incorporate to render some areas of shadow and contrast.

2. Colors are dimmed with the addition of white or gray.

3. The incorporation of gray tones into the greens desaturates color and offers a more harmonious set of colors.

4|

5|

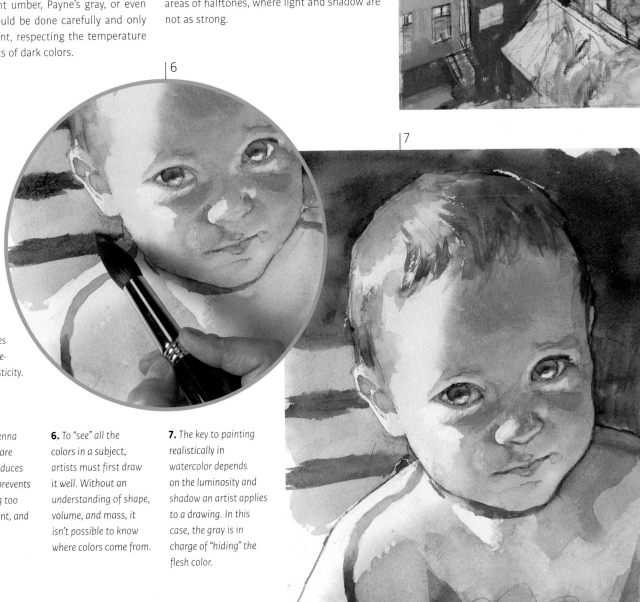

Shading is hiding the color

The artist should see shades from light to shadow, one by one. It is easier to color each shadow plane and finish by applying highlights. Most objects feature shades of color that become darker or grayer depending on their distance from the light source. Light reveals color while shaded areas absorb it. The richness of denser shadows is obtained by adding burnt umber, Payne's gray, or even black. This should be done carefully and only as reinforcement, respecting the temperature and the variants of dark colors.

Desaturated colors

While the best way to desaturate a color is to mix it with white, gray, or black, there is also another equally valid method: mix two colors that are opposites on the color wheel. For example, both of these two mixtures produce grayed colors: orange mixed with its opposite, blue; raw sienna mixed with a cerulean blue. (See also pages 22–23.) Mixed colors appear in areas of halftones, where light and shadow are not as strong.

6|

7|

4. Desaturated colors tend to be grayish or brownish. They harmonize the work, and are excellent for modeling surfaces to achieve a three-dimensional plasticity.

5. Mixed with sienna tones, the blues are grayed, which reduces saturation and prevents them from being too contrasty, strident, and out of place.

6. To "see" all the colors in a subject, artists must first draw it well. Without an understanding of shape, volume, and mass, it isn't possible to know where colors come from.

7. The key to painting realistically in watercolor depends on the luminosity and shadow an artist applies to a drawing. In this case, the gray is in charge of "hiding" the flesh color.

FROM SKETCH TO DETAIL

Fundamental to successfully achieving a realistic representation of a model is a good initial sketch with appropriate tones and stains, followed by good modeling and a working out of the details. A good initial chromatic approach, achieved with sketched and well-structured stains, provides a good foundation for subsequent detail work.

Building slowly

Many artists believe that the best way to build the first outlines is by working quickly and daringly. Nothing could be further from the truth. The first color applications should be very thoughtful, and the tones accurately reflecting the real model as much as possible. This work requires many hours of observation.

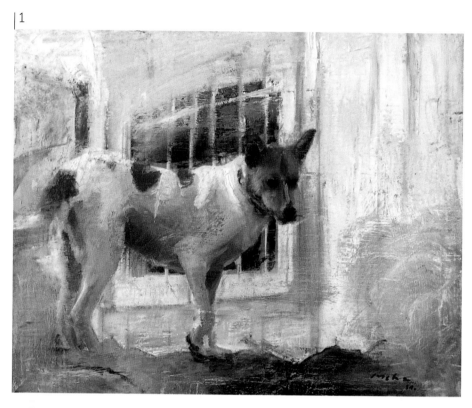

1

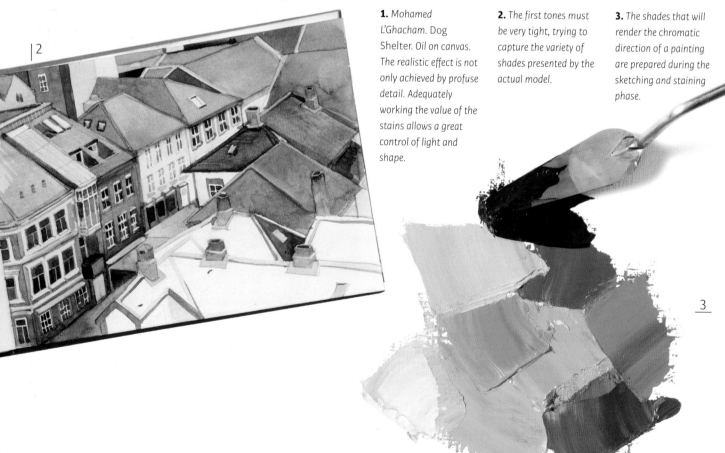

2

3

1. *Mohamed L'Ghacham. Dog Shelter. Oil on canvas. The realistic effect is not only achieved by profuse detail. Adequately working the value of the stains allows a great control of light and shape.*

2. *The first tones must be very tight, trying to capture the variety of shades presented by the actual model.*

3. *The shades that will render the chromatic direction of a painting are prepared during the sketching and staining phase.*

Skin color

Flesh colors are complex and usually represented by combining two methods: direct painting and glazing. Skin texture requires several colors in translucent layers. We only have to observe our hands to see the spots, hair, veins, flesh, and wrinkles on the skin. To achieve good results when painting light-colored skin, you can use white, light pink, ocher or transparent umber red. If the skin is dark, choose burnt tones such as burnt sienna or reds such as English or Indian.

Hair details

When portraying the human figure, one of the most difficult elements to render is hair. This can be accomplished with superimposed stains or sections of color executed with brush strokes that always follow the direction of the hairstyle. To give the impression and feel of real hair, each part of the hairstyle should have shadows and highlights.

4. *Flesh color is not homogeneous. It is necessary to learn how to represent skin using the most neutral pinks to the more brown, warm, or whitened tones.*

4|

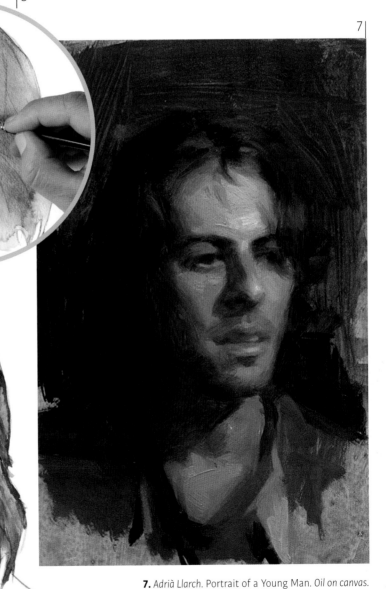

5|

7|

5. *The hairstyle is worked on a flat color base that represents the lighter tones.*

6. *Each section or strand of hair is finished with darker strokes that follow the direction of the hairstyle until a convincing texture is achieved.*

6|

7. *Adrià Llarch. Portrait of a Young Man. Oil on canvas. The changes of hue in the flesh color, as well as the direction of the clearly visible brushstroke, are fundamental to the making of this successful portrait sketch.*

STERLING
New York

An Imprint of Sterling Publishing, Co., Inc.
1166 Avenue of the Americas
New York, NY 10016

ISBN 978-1-4549-2651-1

Distributed in Canada by
Sterling Publishing Co., Inc.
c/o Canadian Manda Group,
664 Annette Street
Toronto, Ontario, Canada M6S 2C8
Distributed in the United Kingdom by
GMC Distribution Services
Castle Place, 166 High Street, Lewes,
East Sussex, England BN7 1XU
Distributed in Australia by NewSouth Books
45 Beach Street, Coogee, NSW 2034, Australia

For information about custom editions,
special sales, and premium and
corporate purchases, please contact
Sterling Special Sales at 800-805-5489 or
specialsales@sterlingpublishing.com.

Manufactured in Spain

2 4 6 8 10 9 7 5 3 1

www.sterlingpublishing.com

Design by Parramón Paidotribo

Mercedes Gaspar.
Sketch of an Interior.
Oil on canvas.